# Hans Hofmann

# Hans Hofmann

By Helmut Friedel and Tina Dickey

Hudson Hills Press
New York

# Acknowledgments

It had long been the desire of the Städtische Galerie im Lenbachhaus to exhibit the paintings of Hans Hofmann, because his work represents a formal link between Kandinsky's work and that of the Abstract Expressionists in New York. At the suggestion of Petra Reed, this wish materialized. I am also grateful to her for helping with the selection of works. I am indebted to the Hans Hofmann Estate for its support through all the stages of the realization of this exhibition, and especially to co-trustee Robert S. Warshaw for providing much of the essential information. The André Emmerich Gallery in New York, André Emmerich himself, and Jun James Yohe stood by us consistently in the numerous matters concerned with this project, and I am very grateful to them, and particularly to Mr. Yohe for his help in securing works from different lenders. I would also like to thank all of our lenders and museum colleagues for providing us with such important and valuable works from their collections, especially Ida Balboul from the Metropolitan Museum of Art and Jacqueline Baas and Larry Rinder of the Berkeley Art Museum (formerly University Art Museum). In addition, I would like to thank everyone else who contributed to the exhibition and this publication, including Tina Dickey, who procured archival photographs and assisted with a variety of other details.

The final word, however, goes to Hans Hofmann himself, who, on the occasion of his exhibition here at the Lenbachhaus in 1962, presented us with his important painting *The Conjurer* (1959). The significance of this generous deed cannot be overestimated, for it served as a starting point for our present exhibition of his late work.

Helmut Friedel
Director, Städtische Galerie im Lenbachhaus, Munich

First English Edition

This book was originally published in German on the occasion of the exhibition "Hans Hofmann: Wunder des Rhythmus und Schönheit des Raumes." The exhibition was on view at the Städtische Galerie im Lenbachhaus in Munich, from 23 April to 29 June 1997 and then traveled to the Schirn Kunsthalle Frankfurt, where it was seen from 12 September to 2 November 1997.

Original German texts © 1997 Verlag Gerd Hatje, Ostfildern-Ruit, and Städtische Galerie im Lenbachhaus, Munich. Illustrations and English translation © 1997, 1998 by the Estate of Renate Hofmann or the artist's assignees. "Spatial Constellations: Rhythms of Nature" © 1997, 1998 by Tina Dickey.

Published in the United States by Hudson Hills Press, Inc., 122 East 25th Street, Fifth Floor, New York, NY 10010-2936.

Distributed in the United States, its territories and possessions, and Canada by National Book Network.
Distributed in the United Kingdom, Eire, and Europe by Art Books International Ltd.

**For Hudson Hills Press**

Editor and Publisher
Paul Anbinder

Copy Editor
Fronia W. Simpson

Proofreader
Lydia Edwards

**For Verlag Gerd Hatje and Städtische Galerie im Lenbachhaus**

Editor
Helmut Friedel

Editing and Coordination
Susanne Böller

English Translation
John Ormrod

Registrars
Susanne Böller, Daniela Müller

Manufactured in Germany by Dr. Cantz'sche Druckerei, Ostfildern/Stuttgart.

Library of Congress Cataloguing-in-Publication Data

Friedel, Helmut.
  [Hans Hofmann. English]
  Hans Hofmann / by Helmut Friedel and Tina Dickey. — 1st ed.
    p.  cm.
  Includes bibliographical references.
  ISBN 1-55595-154-6 (cloth : alk. paper)
  1. Hofmann, Hans, 1880–1966—Criticism and interpretation.
  2. Abstract expressionism—United States.
  I. Dickey, Tina, 1954– .
  II. Hofmann, Hans, 1880–1966.  III. Title.
  ND237.H667F7513  1998
  759.13—dc21
                                   98-18456
                                        CIP

Printed in Germany

759.13
HOFMANN

MW

# Contents

# "To sense the invisible and to be able to create it—that is art." (Hans Hofmann, 1950)

Helmut Friedel

Exhibiting the work of Hans Hofmann in Germany today is the rediscovery of an artist who was one of the foremost teachers and artistic mediators of an entire American generation. Together with Arshile Gorky, Jackson Pollock, Willem de Kooning, Philip Guston, Franz Kline, Robert Motherwell, and Barnett Newman, Hofmann first came to the notice of the German public at the second Documenta exhibition in Kassel in 1959, as an eloquent and forceful witness to the importance of American postwar painting. Accompanied by Guston, Kline, and Theodore Roszak, he represented the United States at the 1960 Venice Biennale, and in the same year took part in an exhibition at the Lenbachhaus under the title "Neue Malerei: Form, Struktur, Bedeutung" (New Painting: Form, Structure, Meaning). Further showings followed in Nuremberg, Cologne, Berlin, and Munich in 1962, and later in Stuttgart and Hamburg. But since 1965, Hofmann's art has rarely been featured in German exhibitions; the only significant ones have been at private galleries such as Michael Haas in Berlin and the Galerie Thomas in Munich. Elsewhere, however, especially in the United States, he has been the subject of several major exhibitions, including those at the Hirshhorn Museum and Sculpture Garden, Washington, D.C., with The Museum of Fine Arts, Houston (1976), The Metropolitan Museum of Art, New York (1980), the Fort Worth Art Museum (1985; now the Modern Art Museum of Fort Worth), the Tate Gallery, London (1988), and the Whitney Museum of American Art, New York (1990). Hofmann's work has also been repeatedly presented by the André Emmerich Gallery in New York, and a comprehensive selection from his oeuvre is on permanent display at the Berkeley Art Museum, University of California (formerly University Art Museum).

Thus a new European presentation of Hans Hofmann's painting, especially of the work from the latter period of his life, between 1950 and 1966, is an event of considerable moment. First, Hofmann's ideas form a crucial link between Wassily Kandinsky and the exponents of Abstract Expressionism, between the European innovations of the early 1900s and the New York School, whose pervasive influence still defines the aesthetic categories and practices of modern art. And second, his unique painting style conveys a deeply personal experience of color that has lost none of its power to fascinate the viewer.

Hans Hofmann was born in Weissenburg in Franconia, Germany, in 1880. His father was a government official and his mother came from a family of brewers. Although his early interests were mainly scientific and musical, he decided at an early age to take up art instead of cultivating his technical talents and began teaching himself to paint by copying old masters at the Alte Pinakothek in Munich. In

1898 he studied briefly with Willi Schwarz, an instructor at the Moritz Heymann School of Art, who introduced him to Impressionism. A generous patron from Berlin, Philipp Freudenberg, then enabled him to leave Munich and the world of academic painting and move to Paris. There he remained from 1903 until 1914, intimately acquainting himself with Impressionism and Post-Impressionism and witnessing the emergence of Fauvism and Cubism at firsthand. Following the fashion of the day, he went regularly to the Café du Dôme, where he met Pablo Picasso, Georges Braque, Juan Gris, and Georges Rouault. Henri Matisse was one of his fellow students in the evening class at the Académie de la Grande Chaumière. In 1908, during Matisse's exhibition at the Cassirer Gallery in Berlin, Hans Purrmann introduced the Frenchman to Hofmann's Berlin patron and collector. Matisse also saw some of his German colleague's paintings and gave an enthusiastic opinion of them. Two years later, Paul Cassirer staged "Hofmann-Kokoschka," Hofmann's first major exhibition. Hofmann's closest friend during the Paris years was Robert Delaunay, with whom he established a continuing dialogue. He was indirectly involved in the genesis of Delaunay's color theory by drawing the attention of his artistic comrade to Georges Seurat's visions of pure color. This interest in Seurat led to a major shift in the direction of Delaunay's work. Delaunay's ideas soon arrived in Munich via contacts with Alexei von Jawlensky, Kandinsky, and Franz Marc. Paul Klee translated Delaunay's essay "On Light" for the journal *Der Sturm*, and an invitation was shortly forthcoming to take part in the first Blue Rider (Blaue Reiter) exhibition, to which he submitted five pictures. Delaunay's art was particularly inspiring to Marc and August Macke. His thoughts on art contain elements of Hofmann's theories:

"As Impressionism progressed, painting discovered light, the light grasped from the depths of feeling as a chromatic organism of complementary values, of paired dimensions that sustain one another, of contrasts on several sides at once. Things that seemed contingent and obvious led in fact to a universal reality with the most profound effect of depth (nous voyons jusqu'aux étoiles). . . . Nature is permeated by rhythms whose variety cannot be restricted. Art imitates it in this respect, in order to clarify itself and thereby attain the same degree of sublimity, raising itself to a state of multiple harmony, a harmony of colors that are divided at one moment and restored to wholeness by the selfsame action at the next. This synchromic action is to be regarded as the real and only subject of painting."[1]

In 1914 Hans Hofmann returned to Munich for family reasons and was taken unawares by the outbreak of World War I. He endeavored to make contact with the remaining members of the Blue Rider circle and immediately became interested in Kandinsky's essay "On the Spiritual in Art," which had been published by Piper in 1912. Gabriele Münter, who was a friend of Hofmann's fiancée Maria (known as "Miz") Wolfegg, asked him to store in his studio a number of paintings by Kandinsky that the latter had been forced to leave behind when he fled from Germany at the beginning of the war. In return for his help, Hofmann was given a watercolor, which stayed with him for the rest of his life: "I would of course very gladly take

1 Robert Delaunay, "Über das Licht," *Der Sturm*, January 1913, pp. 255f.

8

advantage of your kind offer to choose a Kan[dinsky] for myself . . . up to now, the watercolor no. 5 has been hanging in our apartment-cum-studio. . . . I am especially fond of this picture."[2]

As early as 1915, Hofmann founded his own school of art in Munich, at 40 Georgenstraße, with the intention of allowing others to benefit from his knowledge of Cubism and Fauvism and the ideas of Delaunay and Matisse. In a short prospectus, aimed at potential pupils, he offered an initial résumé of his artistic program:

"Art does not consist in the objectivized imitation of reality. Without the creative impulse of the artist, even the most perfect imitation of reality is a lifeless form, a photograph, a panopticon. It is true that, in the artistic sense, form receives its impulse from nature, but it is nevertheless not bound to objective reality; rather, it depends to a much greater extent on the artistic experience evoked by objective reality and the artist's command of the spiritual means of the fine arts, through which this artistic experience is transformed by him into reality in painting. Creative expression is thus the spiritual translation of inner concepts into form, resulting from the fusion of these intuitions with artistic means of expression in a unity of spirit and form, brought about by intuition, which in turn results from the functioning of the entire thought and feeling complex accompanied by vigorous control of the spiritual means. Imitation of objective reality is therefore not creation but dilettantism, or else a purely intellectual performance, scientific and sterile. A work of art is, in spirit and in form, a self-contained whole, whose spiritual and structural relationships permit no individual parts, despite the multiplicity of depicted objects. Every independent element works against the spiritual context, and makes for patchwork, reducing the total spiritual value. The artist must therefore learn the spiritual media of the fine arts, which constitute its form and fundamentals. The artist must create his particular view of nature, i.e., his own experience, be it from nature or independent of it. Through these realizations the assignments of the scholastic years will be clearly understood, ensuring the further development of the artist, who must then detach himself entirely from schools and directions and evolve a personality of his own."

This text clearly shows the influence of Hofmann's experiences in Paris and points, in particular, to the impact on his thinking of Kandinsky's theory of art. The very first sentence calls on the artist to abandon the imitation of reality, and the emphasis on the "spiritual" is extremely marked.

Hofmann spent the 1920s in Munich, where he married Miz in 1924. In 1930 he traveled to the United States, at the invitation of Worth Ryder, a former pupil who was then chairman of the Department of Art at the University of California at Berkeley. Hofmann's close contacts with his former Munich students on the East and West Coasts of the United States enabled him to close his Munich school and leave Germany for good in 1932, shortly before the Nazis seized power. After settling in New York, he began teaching at the Art Students League; one year later, in 1933, he opened his own art school. He became an American citizen in 1941.

2  Letter from Hans Hofmann to Gabriele Münter, 3 June 1927, Gabriele Münter- und Johannes Eichner-Stiftung.

One of Hofmann's early pupils was Lee Krasner, who introduced him in 1942 to Jackson Pollock. The technique of "drip" painting, used by Hofmann for the first time in a picture titled *Spring*, could be seen as evidence of an association with Pollock. But although this work bears the date 1940, scholars now agree that it actually originated in 1944 or 1945, and that *The Wind* (fig. 1), dated 1942, was painted in 1944. The question of priority in the use of dripping—an issue involving far more than merely technical considerations—has been conclusively answered by Cynthia Goodman, who shows that Hofmann did not begin to employ the technique as such until the end of 1943.[3] However, the beginnings of something similar can be found in a watercolor from as early as 1939, which contains splashes and dribbles of color. In any event, these pictures document the existence of a close relationship between Hofmann and his younger colleague. Pollock provided an introduction to Peggy Guggenheim, who gave Hofmann his first solo show at her Art of This Century Gallery in New York.

Up to this point, throughout the 1930s, Hofmann had continued to develop his early style of painting, based especially on the ideas of Matisse and characterized by a preference for still lifes, portraits, and landscape motifs. In the winter of 1938-39, he gave a series of lectures on the theory of art. These were open to outside visitors, as well as his own students, and provided an opportunity to address a wider audience, whose members included Arshile Gorky and Clement Greenberg. From about 1940 onward, his work became more abstract, although clearly identifiable figurative references can still be found in some pictures until about 1950. In the postwar years, Hofmann revived his contacts with Paris, where he had a solo exhibition in 1949 at the Galerie Maeght. However, his renewed encounter with Picasso, Braque, and Brancusi had no obvious influence on the direction of his work. Hofmann taught for over forty years, stopping only at the age of seventy-eight in 1958, and became perhaps the most influential teacher in the contemporary American art world. Among his many pupils were Nell Blaine, Giorgio Cavallon, Burgoyne Diller, Charles and Ray Kaiser Eames, Helen Frankenthaler, Red Grooms, Wolf Kahn, Allan Kaprow, Lee Krasner, Alfred Leslie, George McNeil, Marisol, Joan Mitchell, Louise Nevelson, Larry Rivers, and Richard Stankiewicz. He was regarded as the rival of Josef Albers, another artist-teacher, who had immigrated to the United States in 1933, bringing with him the instruction methods of the Bauhaus and a very different set of ideas, based on the theories of Constructivism. Hofmann's teaching activities often tended to overshadow his artistic achievements, and, in the eyes of the public, the full flourishing of his talents was delayed until the latter years of his life, when he closed his school and devoted all his energies to painting.

Hofmann's late work is characterized by an extraordinary intensity in the treatment of color on the basis of two contrasting principles—on the one hand, the free, spontaneous gesture, and on the other, the austere linearity of the rectangle. It is as if he had succeeded in unifying the two major paradigms of twentieth-century art, as defined by Kandinsky and Piet Mondrian in the years immediately preceding

3 "Hans Hofmann," in *Hans Hofmann*, exh. cat. (Munich: Prestel Verlag, in conjunction with the Whitney Museum of American Art, 1990), pp. 54-56.

World War I. The approach of his gestural paintings, in which the paint is dribbled and sometimes even smeared, is very different from that of the meticulously constructed layerings of colored rectangles. Looking at works such as *The Wind* (1942), *The Ocean, Towering Clouds,* and *Prelude of Spring* (1958), one has the impression that the artist is inviting the viewer to retrace the movements he made in applying the color to the surface. The color is integrated into the rhythm of the painter's touch, which produces a wide range of effects. The materiality of the color establishes a sense of volume and spatial depth, but only in terms of painting itself, instead of "real," three-dimensional space. Directness and solidity give way to a less tangible, mediated quality, to the specific magic of the color as it merges with the canvas. In these pictures, Hofmann allows color to act out a drama of its own making; he provides the basic structure and setting, as it were, but then leaves the material free to realize its inner potential. He uses a variety of textures, ranging from thick, heavy impasto to a thin, aqueous film, and applies the color using knives as well as brushes and pouring or dripping it onto the surface. Thus a dialogue is established between the painter's active and passive presences, between the acts of giving and withdrawing.

Clement Greenberg described this creative process as follows: "Klee and Soutine were perhaps the first to address the picture surface consciously as a responsive rather than inert object, and painting itself as an affair of prodding and pushing, scoring and marking, rather than simply inscribing or covering the flatness of such an object. Hofmann has taken this approach much further than they, and made it do much more."[4] The sense of scoring and digging is evident in the pictures that are constructed with, and dominated by, the rectangle. Rectangles are deliberately partial selections from reality; they are forms of domestication and limitation, of rational intervention, assertively defining top and bottom, left and right. Hofmann's color rectangles have a material density that removes any hint of transparency and leaves them standing as opaque and solid shapes in front of the remaining structure. Sometimes they have the appearance of a mere technical expedient, a novice's aid of the kind with which Hofmann was familiar from his long experience as a teacher. In pictures such as *Equinox* (1958) and *Pompeii* (1959), and especially in *Goliath* (1960), *Combinable Wall I and II* (1961), or *Rhapsody* (1965), the rectangles look like paper cutouts that have been shuffled back and forth on the canvas until the artist has found the right positions for them. Thus Hofmann establishes a flexible pictorial system that allows infinite scope for variation, in the sizing and placing of shapes, and in modulating the relationships of color to space and to other colors. It is a system in which the artist is the central actor, the controlling and determining instance. In this respect, Hofmann's thinking is akin to that of Mondrian, who in 1942 offered the following comments on "pure" painting:

"Unconsciously, every true artist has always been moved by the beauty of line, color, and relationships for their own sake and not by what they may represent. He has always tried to express all energy and all vital richness by these means alone.

**4** Clement Greenberg, "Hans Hofmann: Grand Old Rebel," *Art News* 57, no. 9 (January 1959): 29, 64.

Nevertheless, consciously he has followed the forms of objects. Consciously, he has tried to express things and sensations through modelling and technique. But unconsciously, he has established planes, he has augmented the tension of line and purified the color. Thus gradually through centuries, the culture of painting has led to the total abolition of the limiting form and particular representation. . . . In Nature, a complete deliverance from tragic feeling is not possible. In life, where the physical form is not only necessary but of the greatest importance, equilibrium will always be very relative."[5]

Hofmann's artistic range is therefore exceptionally broad. It extends from the exact delineation of formal relationships—taking up ideas that were to be found in the work of Mondrian and Kasimir Malevich and developed further during Hofmann's own time in New York by painters such as Ad Reinhardt and Barnett Newman—to a kind of free creation based entirely on action and gesture, on the immediate rendering of an emotional or psychological state. This was the concept of art espoused by Pollock, de Kooning, James Brooks, and other kindred spirits. Hofmann himself speaks quite openly of a felt tension between head and heart, rational thinking and raw feeling:

"The magic of painting, however, can never be fully, rationally explained. It is the harmony of heart and mind in the capacity of feeling into things that plays the instrument. The instrument answers the throb of the heart in every instance. Painting is always intuitively conditioned. Theoretically it is a process of metabolism, whereby color transubstantiates into vital forces that become the real sources of painterly life. These sources are not of a physical but rather of a hyper-physical nature—the product of a sensitive mind. Pictorial life is not imitated life; it is, on the contrary, a created reality based on the inherent life within every medium of expression. We have only to awaken it."[6]

Hofmann also refers to Kandinsky's previously formulated idea of the analogy between chromatic and musical scales. He, too, sees each scale as having its own specific rhythm:

"The rhythmic development of the red scale differs from that of the blue scale or the yellow scale, etc. The development of the color scales spreads over the whole picture surface, and its orientation, in relation to the picture surface, is of utmost importance."[7]

An immediately striking feature of Hofmann's work is the expressive titles of his paintings, which often speak of landscapes and moods of nature. Among the examples that spring to mind are *The Ocean, Prelude of Spring, Equinox, In the Wake of the Hurricane, Agrigento, Lumen Naturale, Rhapsody, Little Cherry, Deep within the Ravine, Summer, Renate's Nantucket,* and *The Southwind.* These titles seem to guide the viewer along a certain perceptual path. They are colored by the knowledge of specific places, by personal memories of particular seasons and times of day, by general and specific associations with music. Latin titles such as *Conjunctis Viribus, Nulli Secundus, Imperium in Imperio, Pax Vobiscum, Magnum Opus,* or *Lumen Naturale* signify an effort to recollect and reaffirm a set of historical and geographical roots.

**5** "Pure Plastic Art," March 1942, in *Plastic Art and Pure Plastic Art, 1937, and Other Essays, 1941-1943,* ed. Robert Motherwell, Documents of Modern Art Series (New York: Wittenborn & Co., 1945), p. 31.

**6** "The Color Problem in Pure Painting—Its Creative Origin," first published in *Hans Hofmann: New Paintings,* exh. cat. (New York: Kootz Gallery, 1955), reprinted in *A Retrospective Exhibition of Hans Hofmann,* exh. cat. (New York: Whitney Museum of American Art, 1957), and in Sam Hunter, *Hans Hofmann* (New York: Harry N. Abrams, 1963), p. 46.

**7** "The Color Problem in Pure Painting," in Hunter, *Hans Hofmann,* p. 46.

They are informed by the culture of the Mediterranean region, as embodied in the Roman Catholic church and the traditions of the classically educated European middle class. The titles often have a ring of mystery and solemnity. Some of them establish connections with actual living persons, or with historical or biblical figures charged with symbolic significance, as, for example, in *Goliath* or *To JFK: A Thousand Roots Did Die with Thee*. There are also direct references to the artist's own life: *To Miz: Pax Vobiscum* is a memorial to his first wife, while *Renate's Nantucket* alludes to his late second marriage.

In every case, the question arises of how the work relates to the title. It is obvious that the paintings are not mere illustrations, but do they have some other, less direct mimetic function? Looking at *In the Wake of the Hurricane*, for example, one senses that the violence of the natural phenomenon to which the title refers is reflected in the rhythmically organized application of the color and the animated wildness of the structures. Similarly, the earthy roughness of the colors in *Agrigento* recalls the landscape of southern Sicily, and *Pompeii* conveys something of the buried Roman town with its eponymous shade of red. Thus the titles make it possible to establish connections with certain colors and forms. But Hofmann approaches representation indirectly, in terms of analogy rather than anecdote. A case in point is *To JFK: A Thousand Roots Did Die with Thee*, his large black canvas referring to the assassination of the American president. Here, the paint is splashed and dribbled in a way that suggests a pool of red blood, while the pure negative black conveys a general feeling of gloom and menace. The relationship of title and motif is one of reciprocal give-and-take, or push-and-pull, echoing the dynamic conception of the other principles that underlie his painting. The movement is free and flowing, alternating between submission and deliberate intervention.

Hofmann uses titles in a manner reminiscent of Paul Klee, as a means of complementing the image, sometimes moving far away from the motif and sometimes tracking it very closely, giving it an additional twist at a literary level and thereby enhancing its meaning. The ambivalence of the titles, hovering uncertainly above the actual events on the canvas, manifests itself equally in the application of the various pictorial principles in the painting itself. As well as speaking of the oscillation between constructive, rectangular elements and a free gestural style, Hofmann describes the spatial construction of the pictures, and the relationship between plane and space, as a dialectical process:

"The depth problem is one of the most controversial problems in pictorial creation. It is hard for the layman to understand that a pure two-dimensional projection on a flat surface should result in a three-dimensional realization without destroying the two-dimensionality of the picture. . . . But pictorial space is an aesthetically created space and is as such as real as nature. Its reality is based on the reality of the hidden inherent laws of the picture surface. The entire depth problem in the visual arts culminates in this way in an emotionally controlled aesthetic projection into the hidden laws of the picture surface. What we experience in nature 'conceptionally' [*sic*] as depth is transformed on the picture surface in an act of

shifting. The physical carriers in the act of shifting are the pictorial means employed vigorously in the act of creation—points, lines, and planes, with diversity of color, light and shadow, or tonal gradation as their attribute or color in an independent function, as in pure painting. But depth is not an inert thing. Depth means non-emptiness. Depth has volume as the object has and this volume is created by pictorial placement combined with color saturation. Depth as we experience it in nature is for our conceptional [sic] experience as concrete as objects are. Depth and object make the entity of space. Space is alive, dynamic, fluctuating, and ambiguously dominated by forces and counter-forces, by movement and counter-movement, all of which summarize into rhythm and counter-rhythm as the quintessence of life-experience. The inherent laws of the picture surface permit the handling of the pictorial development in complete accordance with the experience of nature when we know how to activate pictorial means to reciprocal plastic and psychological response. For this reason it is important to be aware that every plastic activation of the picture surface creates not only real two-dimensional motion on this surface but at the same time three-dimensional 'suggested' motion in the sense of push and pull, that is, in the sense of 'in and out' of depth."[8]

Hofmann's oeuvre reached its biographical conclusion, and perhaps its formal apogee, with the series of pictures dedicated to his young second wife, Renate, following *To Miz: Pax Vobiscum*, the remarkable painting that he made in 1964, at the age of eighty-four, as a monument to his first marriage. *Legends of Distant Past Days, Renate's Nantucket, Summer,* and *Art Like Love Is Dedication* speak of a newfound zest for life. *To Miz: Pax Vobiscum* is not a requiem, but a celebration. The center of the picture is dominated by a powerful triad—a golden yellow oblong shape framed in red, blue, green, and ocher, evoking an atmosphere of commemorative intensity. *Summer* (1965), from the *Renate* series, also features red, blue, and yellow rectangles, but in this case, the shapes are connected by other areas of blurred color and structured against a light background. In this picture, one finds something of the lightness that Hofmann had already introduced in works such as *Prelude of Spring* (1958), where the painting is almost like watercolor. Rather than embodying a continuing development, his works of this period seem to employ two corresponding principles in varying proportions. Order, structure, and system alternate with a lighter style whose fleeting forms can vanish without trace. The two principles are united in pictures such as *The Conjurer* (1959), where a single rectangle penetrates through the seething masses of color, or *Vanquished,* from the same year, in which the spots and splashes of black attempt to displace the rigidly structured color rectangles. All Hans Hofmann's paintings share an exuberant sense of color, a skill in combining pigment with light that suffuses the pictures with a vibrant glow.

"In the act of predominance and assimilation, colors love or hate each other, thereby helping to make the creative intention of the artist possible."
Hans Hofmann, 1959

8 Hofmann, "The Resurrection of the Plastic Arts," in *Hans Hofmann: New Paintings,* exh. cat. (New York: Kootz Gallery, 1954), reprinted in Hunter, *Hans Hofmann,* p. 44.

# Colorplates, 1942–1965

Works marked with an asterisk (*) were
not included in the Lenbachhaus exhibition.
In dimensions, height precedes width.

**1 The Wind, 1942**★

Oil, Duco, gouache, and India ink on poster board,
$43^{7}/_{8}$ x 28 inches
Berkeley Art Museum, University of California,
Gift of the artist

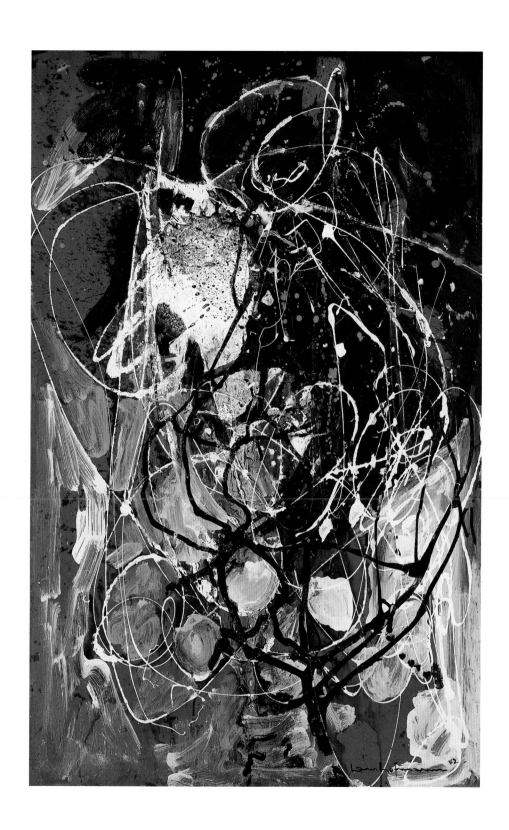

**2  Le Gilotin, 1953**★

Oil on canvas, 58 x 48 inches
Berkeley Art Museum, University of California,
Gift of the artist

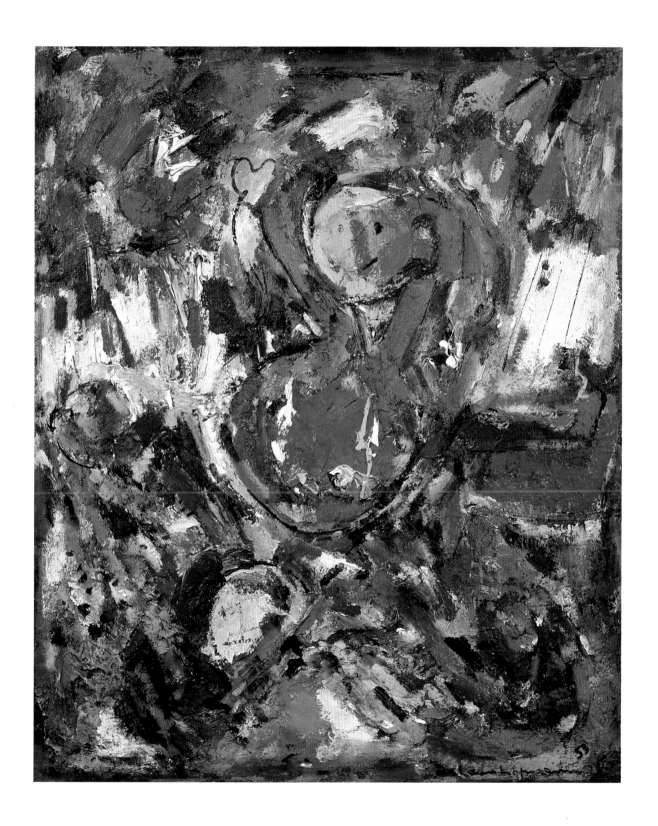

**3 The Ocean, 1957**

Oil on canvas, 60 x 71$^7/_8$ inches
Onnasch Collection, Berlin

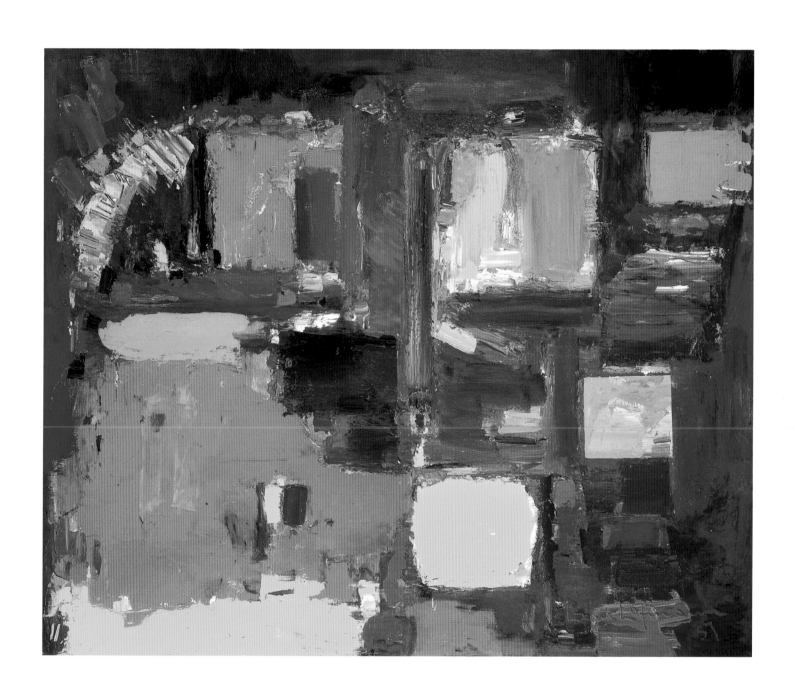

**4  Towering Clouds, 1958**

Oil on canvas, 50 x 84 inches
Private collection

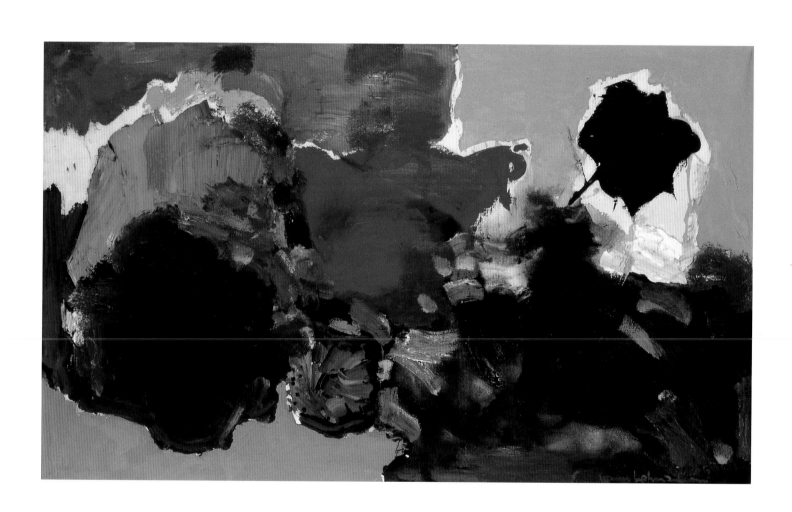

**5  Prelude of Spring, 1958**

Oil on canvas, 50$^{1}/_{4}$ x 84$^{1}/_{4}$ inches
Hirshhorn Museum and Sculpture Garden,
Smithsonian Institution, Washington, D.C.,
Gift of the Joseph H. Hirshhorn Foundation, 1966

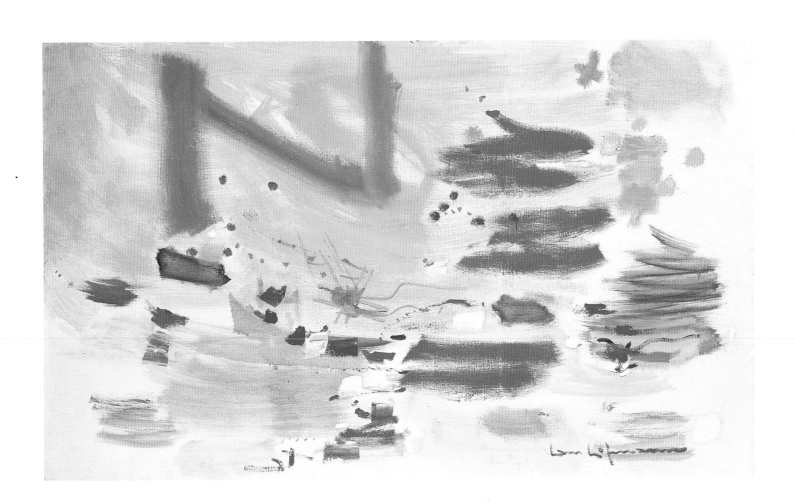

**6 Equinox, 1958**

Oil on canvas, 71 1/8 x 60 1/4 inches
Berkeley Art Museum, University of California,
Gift of the artist

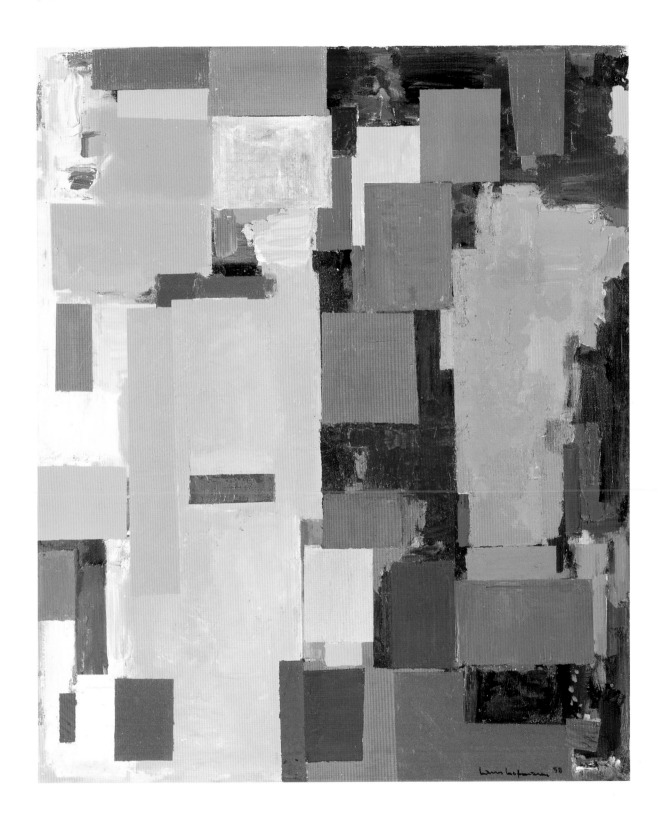

7 **Pompeii, 1959**

Oil on canvas, 84$^1/_2$ x 58$^1/_8$ inches
Tate Gallery, London

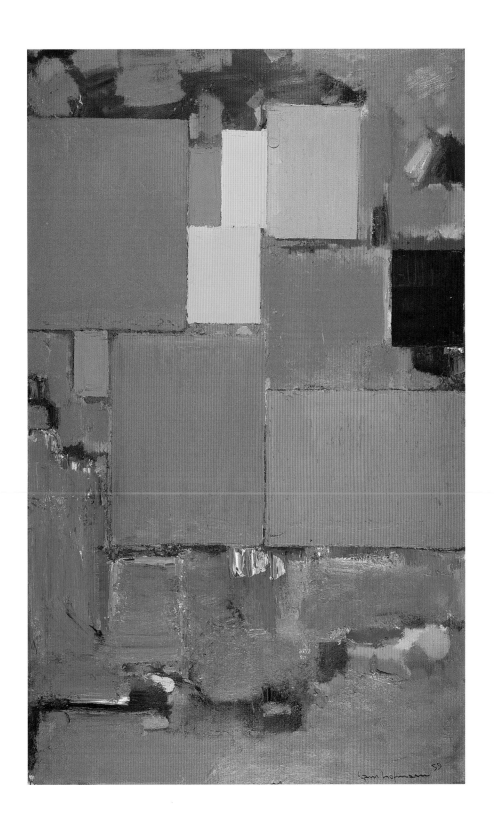

**8  Jardin d'Amour, 1959**

Oil on canvas, 60 x 72 inches
Private collection

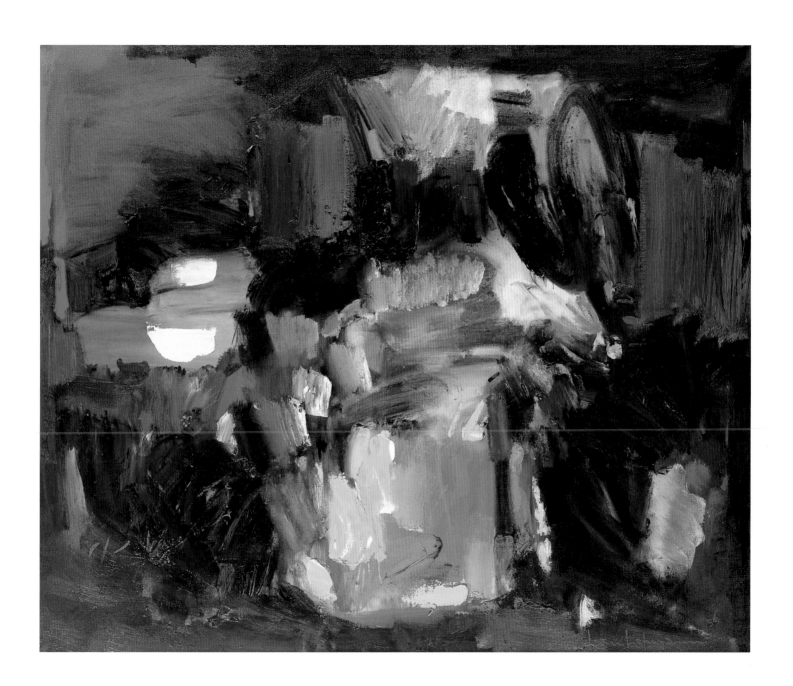

**9 The Vanquished, 1959**

Oil and Duco enamel on canvas,
36 $^1/_8$ x 48 $^1/_8$ inches
Berkeley Art Museum, University of California,
Gift of the artist

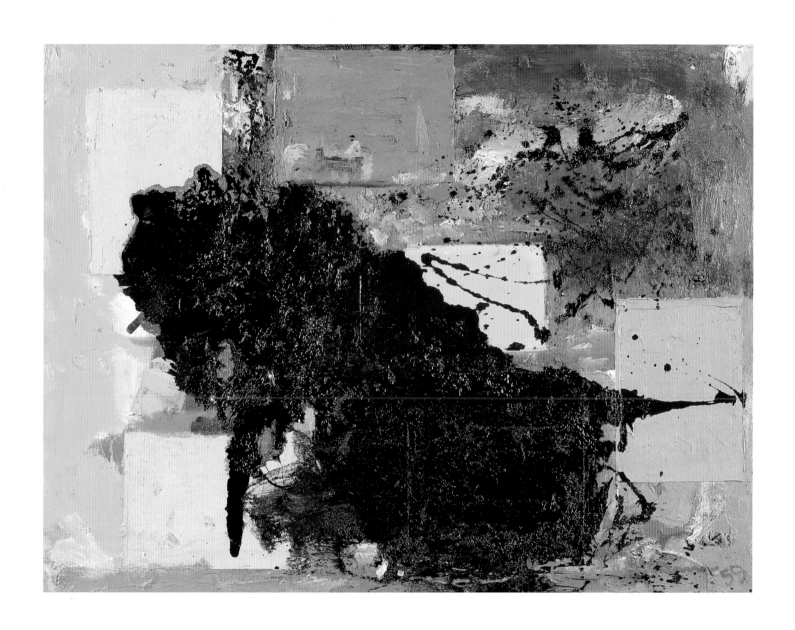

**10  The Conjurer, 1959**

Oil on canvas, 59 1/4 x 44 7/8 inches
Städtische Galerie im Lenbachhaus, Munich

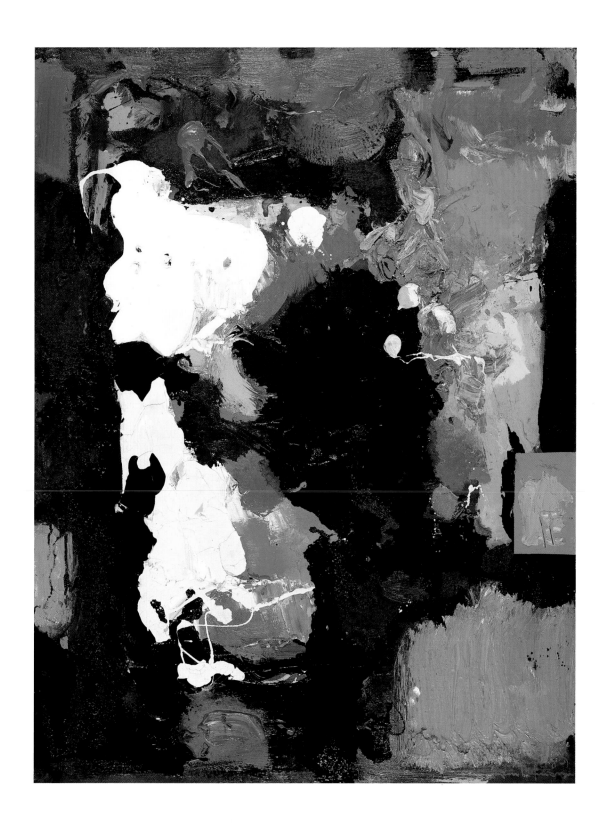

**11  Goliath, 1960**
Oil on canvas, 84$^1/_8$ x 60 inches
Berkeley Art Museum, University of California,
Gift of the artist

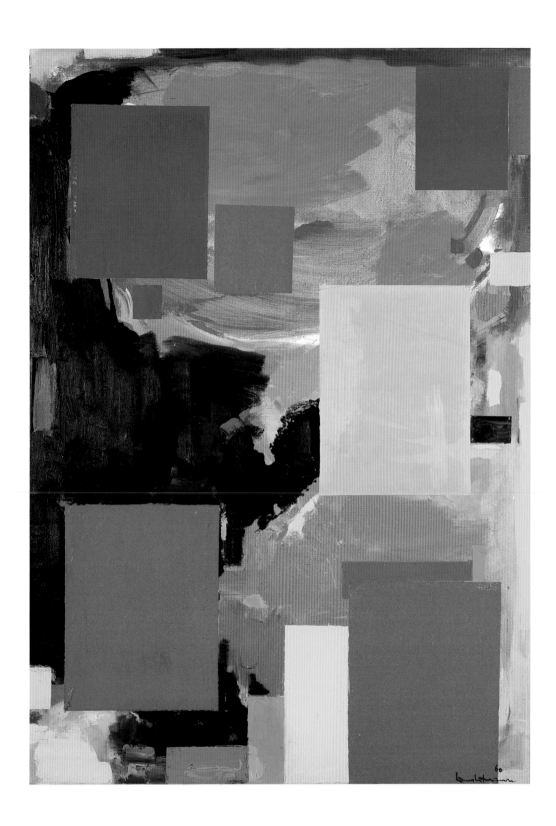

**12  In the Wake of the Hurricane, 1960**

Oil on canvas, 72$^{1}/_{4}$ x 60 inches
Berkeley Art Museum, University of California,
Gift of the artist

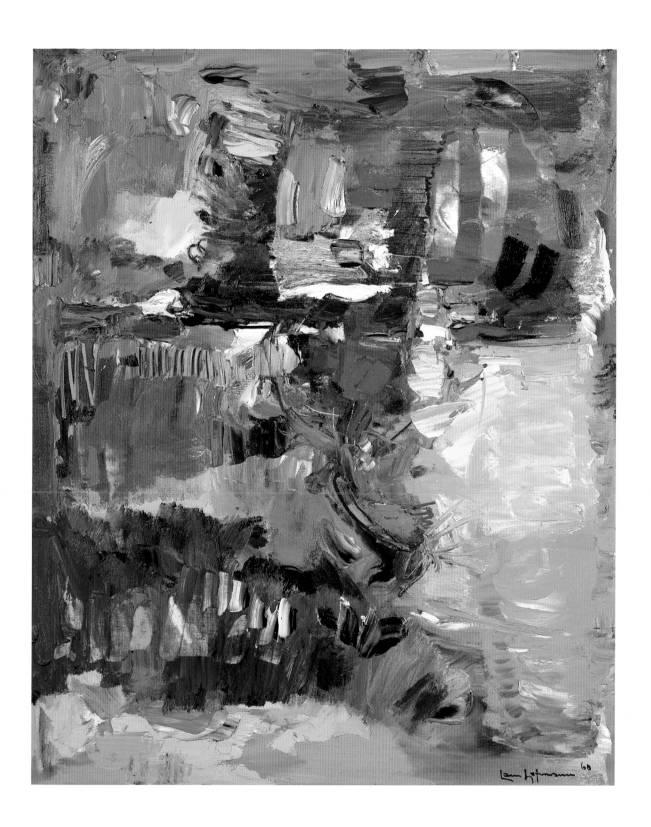

**13 Agrigento, 1961**

Oil on canvas, 84 1/4 x 72 inches
Berkeley Art Museum, University of California,
Gift of the artist

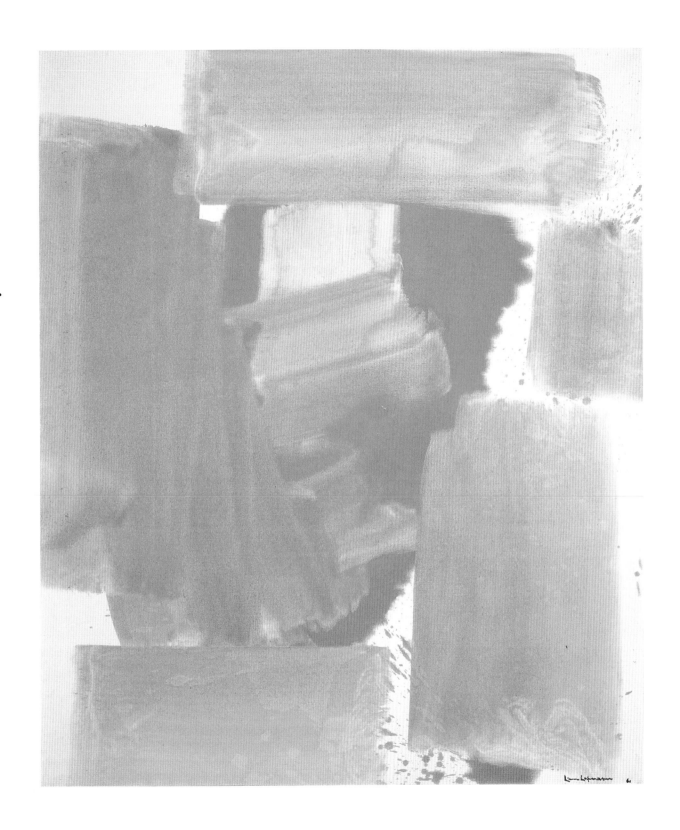

**14  Combinable Wall I and II, 1961** *

Oil on canvas, 84$^{1}/_{2}$ x 112$^{1}/_{2}$ inches
Berkeley Art Museum, University of California,
Gift of the artist

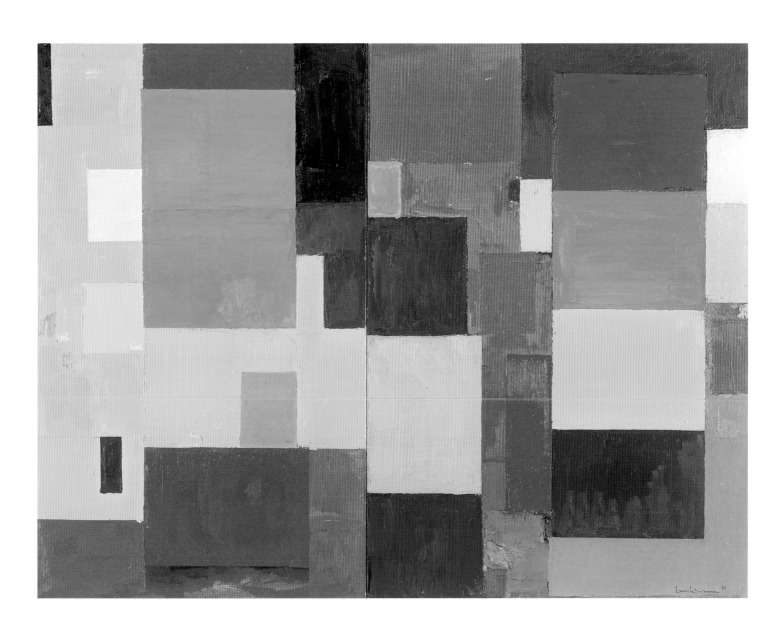

**15  The Vendetta, 1962**

Oil on canvas, 50 x 39 3/4 inches
Galerie Michael Haas, Berlin,
and Crane Kalman Gallery, London

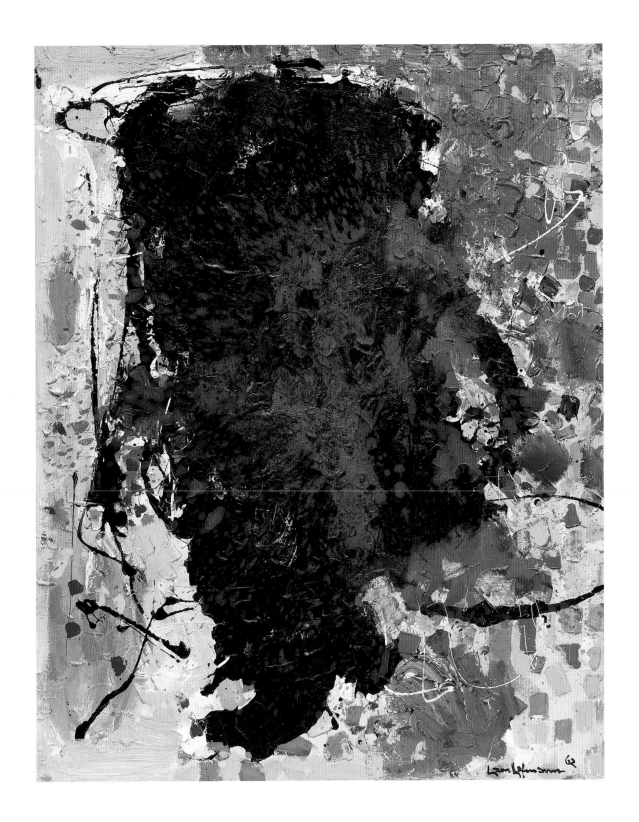

**16  Magnum Opus, 1962**

Oil on canvas, 84 1/8 x 78 1/8 inches
Berkeley Art Museum, University of California,
Gift of the artist

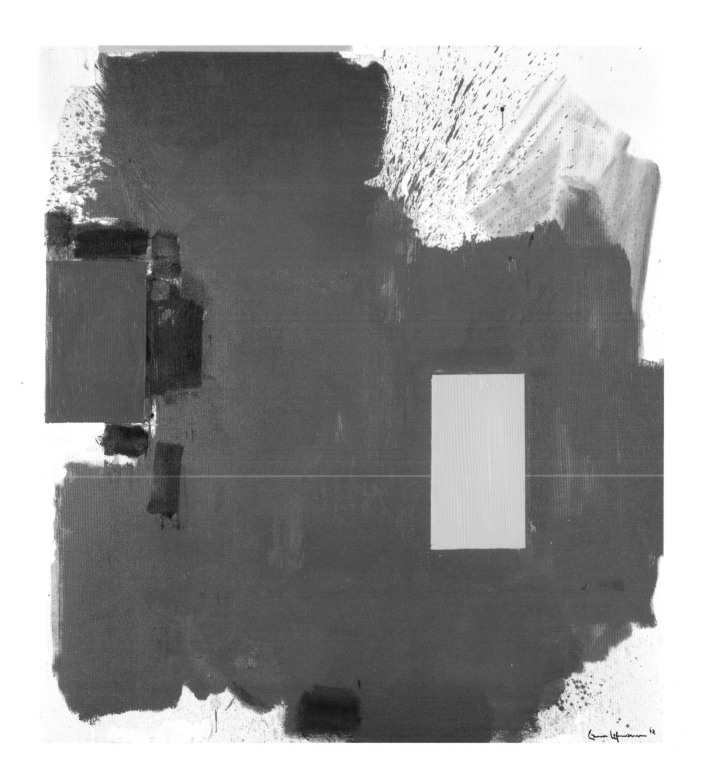

**17 Lumen Naturale, 1962**

Oil on canvas, 84 x 77 $^{11}/_{16}$ inches
Philadelphia Museum of Art,
Purchased with the John Howard McFadden, Jr., Fund

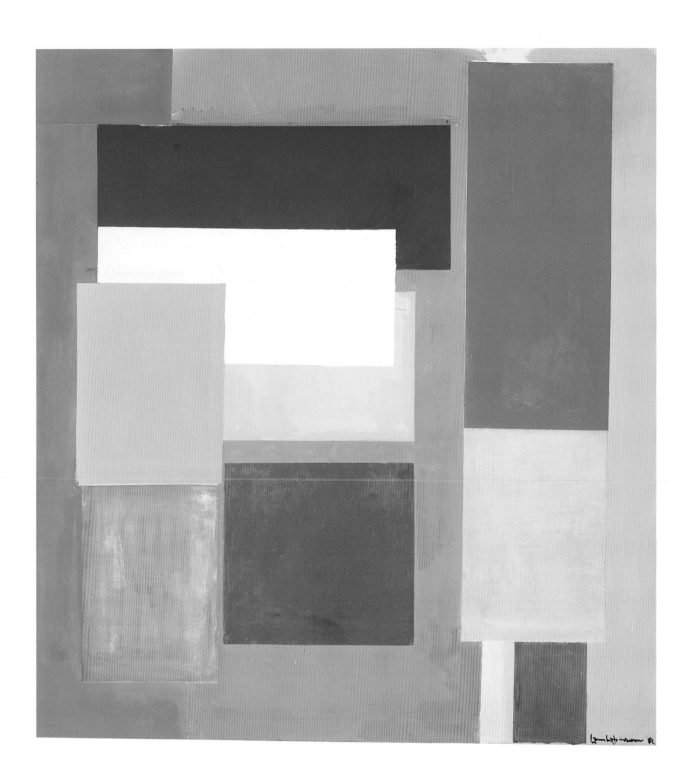

**18 Polyhymnia, 1963**

Oil on canvas, $72^{1}/_8$ x $60^{1}/_4$ inches
Berkeley Art Museum, University of California,
Gift of the artist

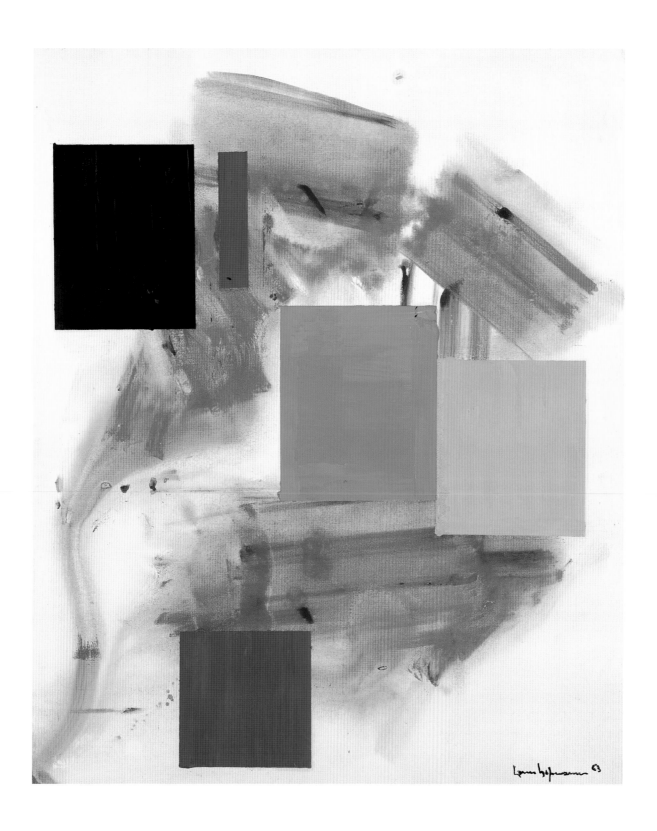

**19  To JFK: A Thousand Roots Did Die with Thee, 1963**

Oil on canvas, 60 x 72 inches
Hirshhorn Museum and Sculpture Garden,
Smithsonian Institution, Washington, D.C.,
Gift of Mr. and Mrs. Leigh B. Block, Chicago, 1976

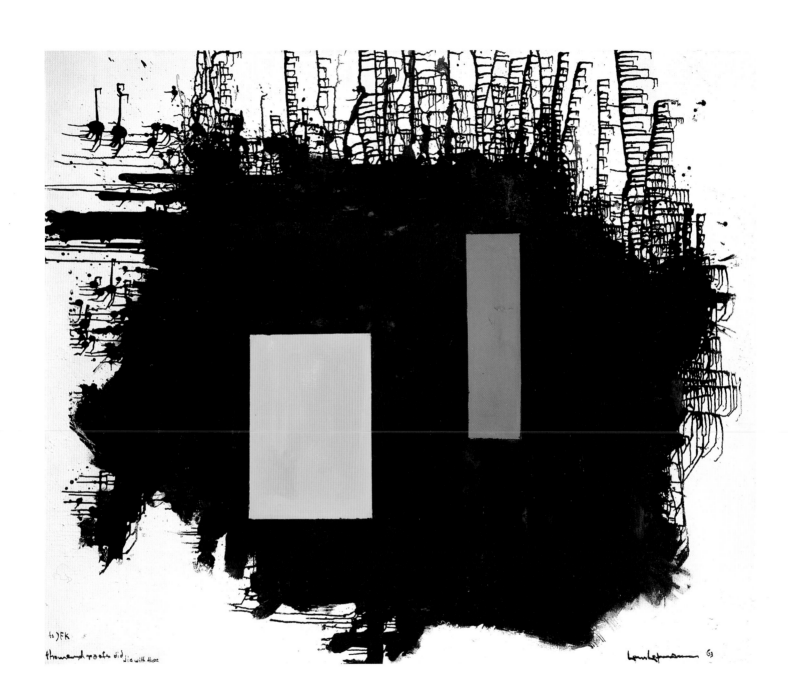

to JFK

thousand roofs did die with thee

Lou Lefinstinann 63

**20  Conjunctis Viribus, 1963**

Oil on canvas, 72 x 60 inches
Onnasch Collection, Berlin

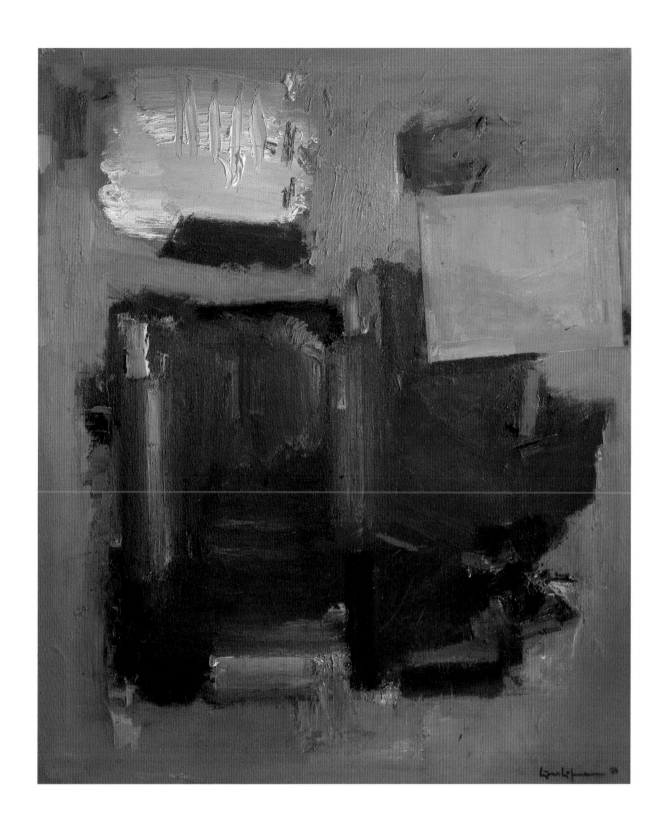

**21 Nulli Secundus, 1964**

Oil on canvas, 84¼ x 52 inches
Tate Gallery, London

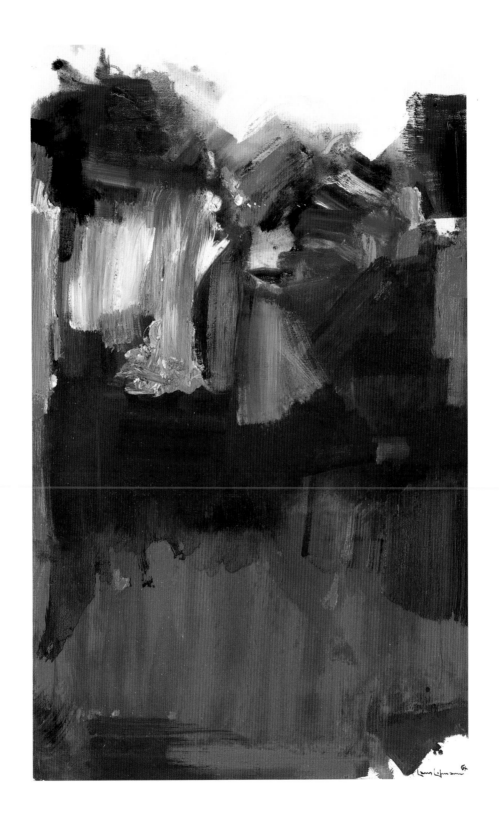

**22 Imperium in Imperio, 1964**

Oil on canvas, 84 1/8 x 52 inches
Berkeley Art Museum, University of California,
Gift of the artist

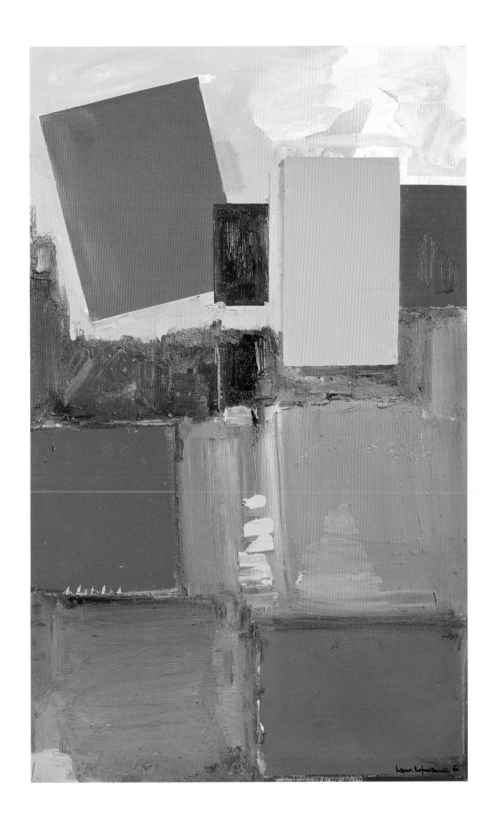

**23  To Miz: Pax Vobiscum, 1964**

Oil on canvas, 78 x 84 inches
Modern Art Museum of Fort Worth

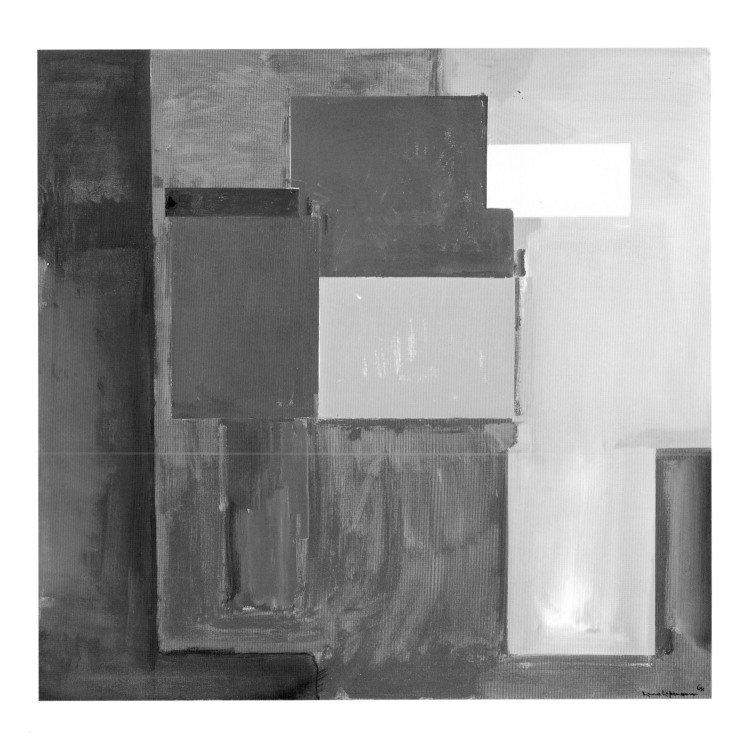

**24  Rhapsody, 1965**

Oil on canvas, 84$^1/_4$ x 60$^1/_2$ inches
The Metropolitan Museum of Art, New York,
Gift of Renate Hofmann, 1975 (1975.323)

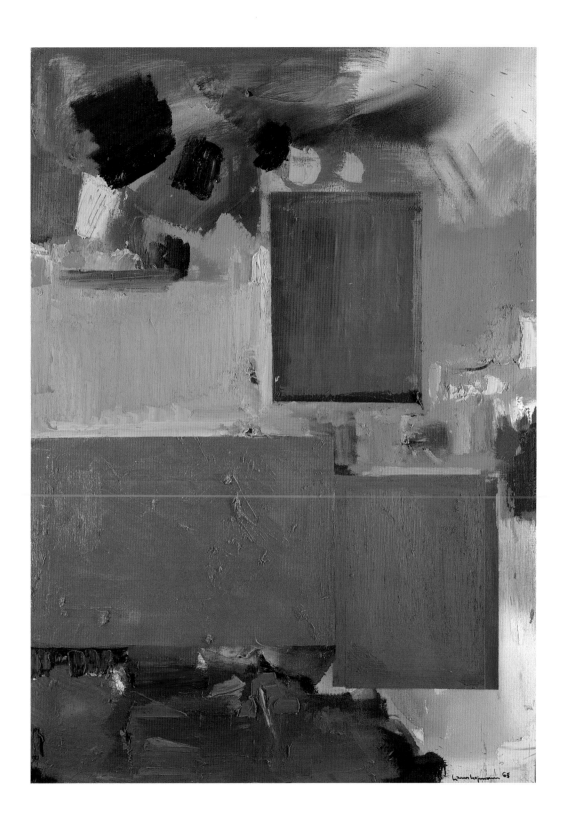

**25 Deep within the Ravine, 1965**

Oil on canvas, 84 1/4 x 60 3/8 inches
The Metropolitan Museum of Art, New York,
Bequest of Renate Hofmann, 1992 (1996.440.3)

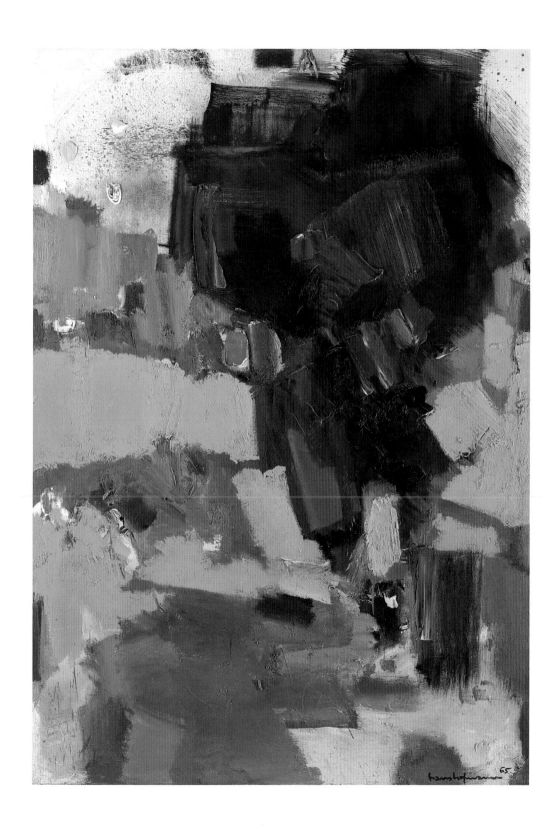

**26 Little Cherry, 1965**

Oil on canvas, 85 1/4 x 78 3/8 inches
The Metropolitan Museum of Art, New York,
Bequest of Renate Hofmann, 1992 (1996.440.1)

**27 Summer, 1965**

Oil on canvas, 72 x 48 inches
The Metropolitan Museum of Art, New York,
Gift of Renate Hofmann, 1991 (1991.428.1)

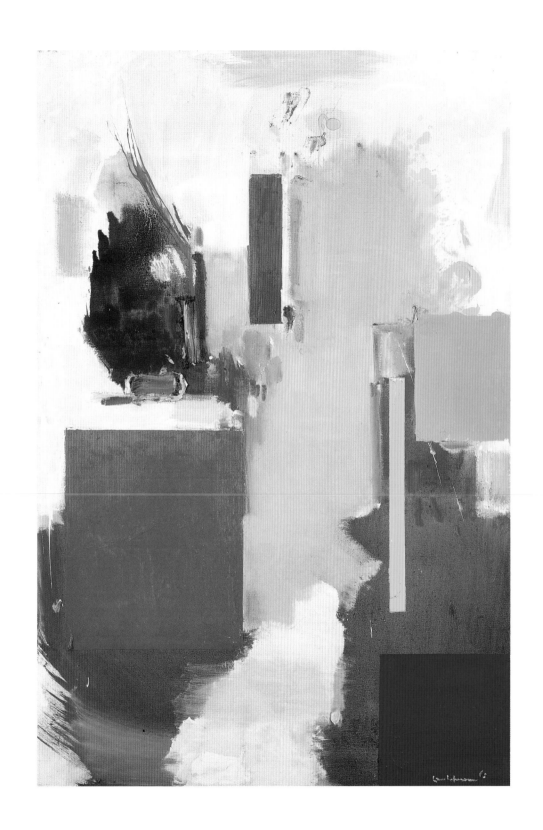

**28  Profound Longing, 1965**

Oil on canvas, $50^{1}/_{8}$ x $40^{1}/_{8}$ inches
The Metropolitan Museum of Art, New York,
Gift of Renate Hofmann, 1990 (1990.342)

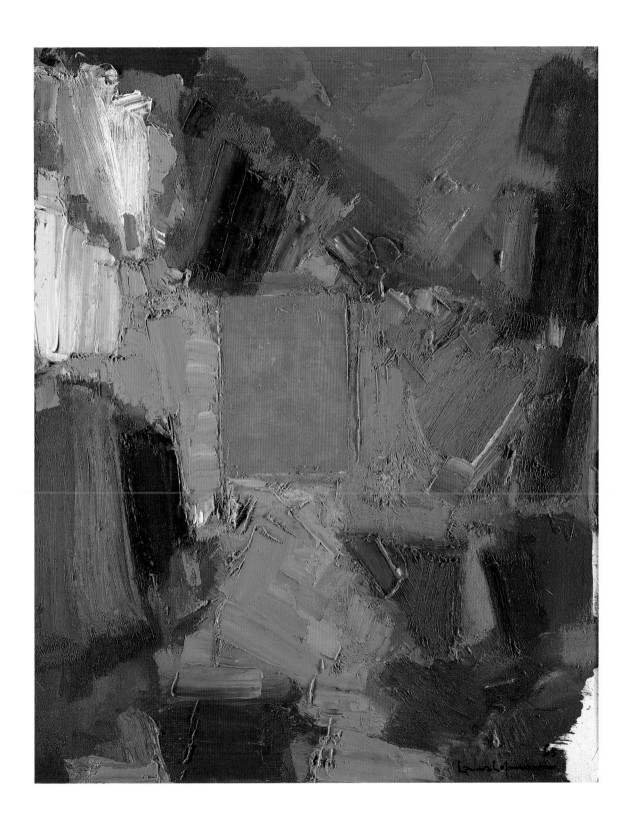

**29  Legends of Distant Past Days, 1965**

Oil on canvas, 40¼ x 50¼ inches
The Metropolitan Museum of Art, New York,
Bequest of Renate Hofmann, 1992 (1996.440.2)

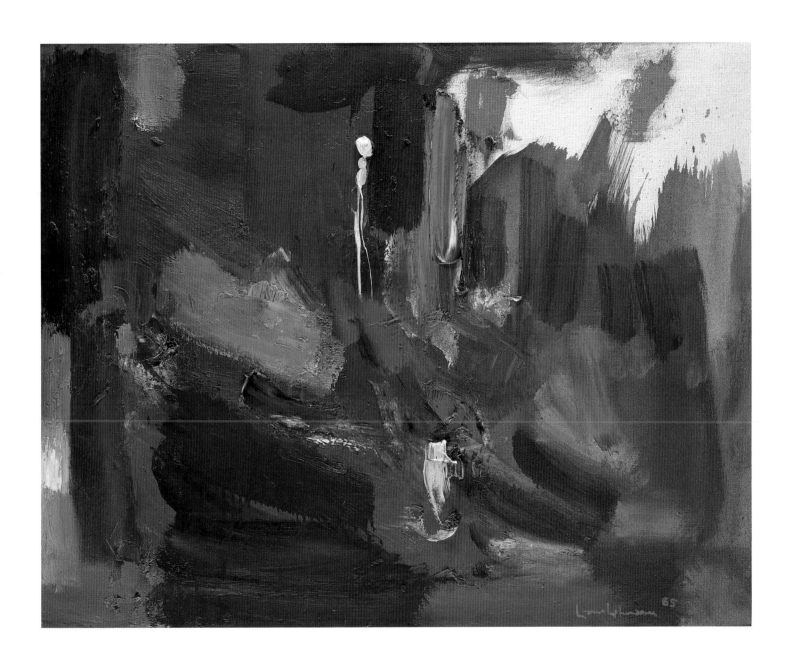

**30 Renate's Nantucket, 1965**

Oil on canvas, 60 x 72 inches
The Metropolitan Museum of Art, New York,
Bequest of Renate Hofmann, 1992 (1996.440.4)

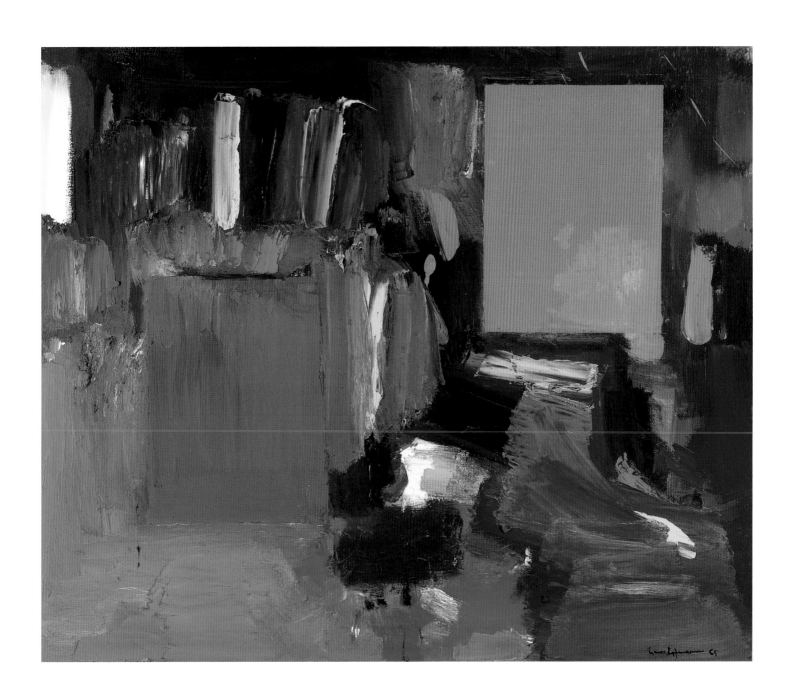

**31 The Southwind, 1964**

Oil on canvas, 59$^7/_8$ x 48 inches
Private collection, Courtesy Sotheby's/
André Emmerich, New York

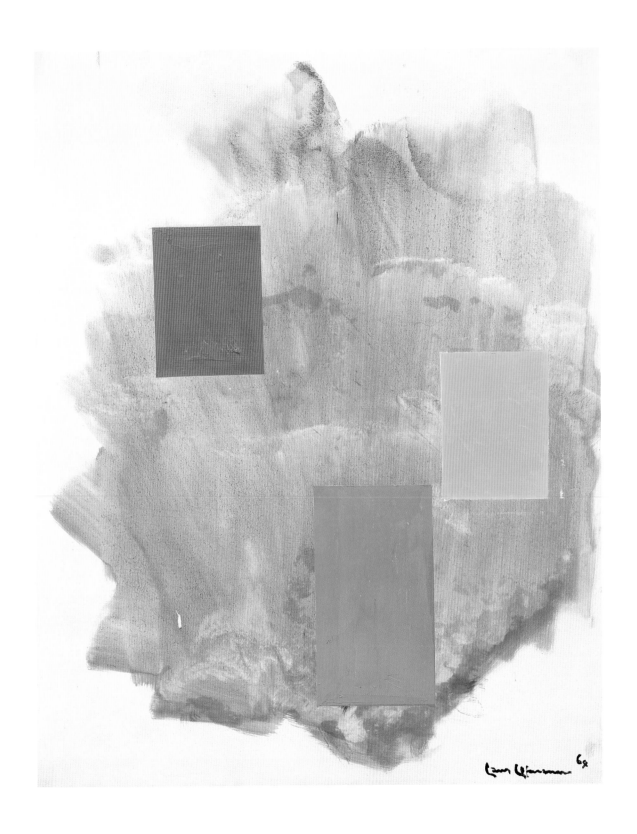

**32 Art Like Love Is Dedication, 1965**

Oil on canvas, 60 1/8 x 52 inches
Yale University Art Gallery, New Haven,
Gift of Susan Morse Hilles

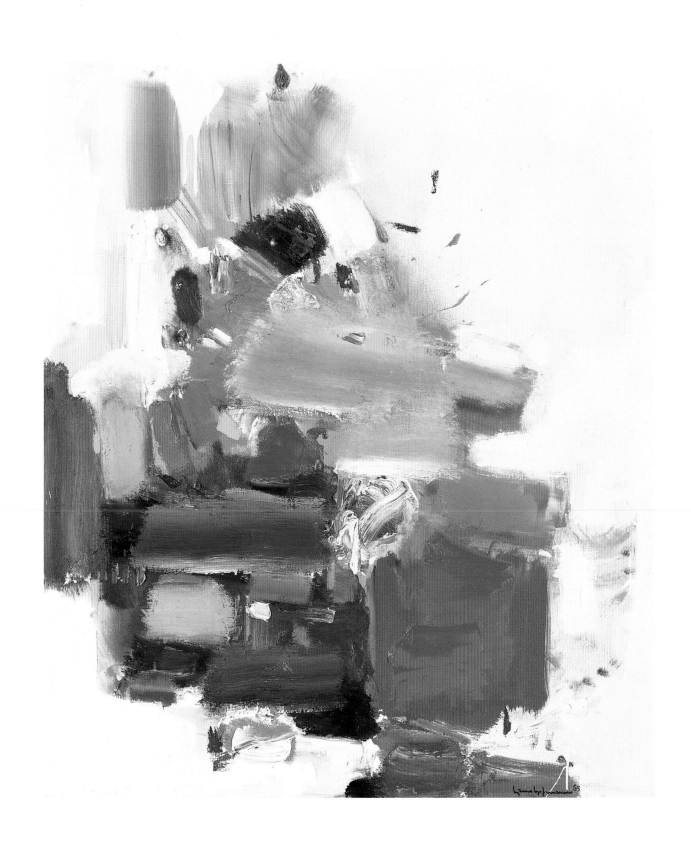

# Spatial Constellations: Rhythms of Nature

Tina Dickey

**1** The article portrayed the school as a "head-quarters for a new approach to art which eventually burst into abstract expressionism, the uninhibited style whose most famous exponent was Jackson Pollock." *Life* 42, no. 14 (8 April 1957), p. 70.

**2** Robert Coates referred to the paintings in Hofmann's 1946 Mortimer Brandt Gallery show as "uncompromising representatives of what some people call the spatter-and-daub school of painting and I more politely have christened abstract expressionism." Robert Coates, "The Art Galleries, at Home and Abroad," *New Yorker* 22, no. 7 (30 March 1946), p. 83. See Irving Sandler, *The Triumph of American Painting: A History of Abstract Expressionism* (New York: Praeger, 1970), p. 2 and notes. Barr's use of the term was noted by William C. Seitz (Ph.D. diss., Princeton University, 1955), p. 448, cited by Sandler. Kandinsky himself referred to the "power and depth of expression of abstract forms." Wassily Kandinsky, *Point and Line to Plane* (*Punkt und Linie zu Fläche;* Bauhaus, 1926) (1947; New York: Dover Publications, 1979), p. 30. Suggested to the author by James Gahagan, former associate director of the Hofmann School (1953–58, monitor, 1952), in conversation, Woodbury, Vt., 23 May 1994.

**3** Hans Hofmann, "Art in America," *Art Digest* 4, no. 19 (August 1930), p. 27.

**4** Irving Sandler, "Hans Hofmann: The Pedagogical Master," *Art in America* 61 (May 1973), p. 49.

**5** Clement Greenberg, "Art," *Nation* 160, no. 16 (21 April 1945), p. 469.

The life and work of Hans Hofmann embody the dialogue America has long sustained with European art. He immersed himself in the artistic communities of both continents, mirroring the collaborative spirit of the Fauves and Cubists into the wayward and unpredictable development of American modern art. His unrelenting exploration of the possibilities of modern art led to an astounding range of work that often presaged the work of his peers.

By the 1960s, Hofmann was called the "father of Abstract Expressionism." His pivotal role was so obvious in the 1960s that *Life* magazine erroneously credited his school as the source of the style.[1] In fact, the label "Abstract Expressionism," used in 1929 by Alfred Barr to describe Wassily Kandinsky's early improvisations, was first applied to the work of the group in an article reviewing a Hofmann exhibition.[2] Hofmann could more accurately be called a catalyst and nexus of the movement.

Extraordinarily sensitive to the need for a purely American painting, Hofmann wrote as a recent immigrant in 1930: "American cultural development at present seems like a process of reaction from the influences of all parts of the world. And, as with a chemical reaction, this process needs time to produce a specific American spiritual life having its expression, later, in a specific American style."[3] His presence in New York in the 1930s made a great impact on Arshile Gorky, Willem de Kooning, Jackson Pollock, and many others because he was able to explain Cubism more clearly than anyone else, and the vanguard artists wanted to learn all they could about Cubism to catch up with the modern painting of Europe. Sheldon Cheney used Hofmann's incomplete manuscript "Form und Farbe in der Gestaltung: Ein Lehrbuch für den Kunstunterricht" as the basis for his *Expressionism in Art*, which began the spread of Hofmann's ideas in 1934. By 1937, almost half the charter members of the American Abstract Artists were former Hofmann students.[4] His popular 1938–39 public lectures inspired the young Clement Greenberg, later an influential critic, to write in 1945: "Hofmann has not yet published his views, but they have already directly and indirectly influenced many, including this writer—who owes more to the initial illumination received from Hofmann's lectures than to any other source."[5]

Those who later became Abstract Expressionists held their first exhibits together in the early 1940s in a Surrealist gallery, Peggy Guggenheim's short-lived Art of This Century, a gallery of unusual design by Frederick Kiesler. Their work in these years shows a fascination with Surrealist imagery. Like Mark Rothko, Pollock, de Koon-

ing, and others, Hofmann was influenced by the Surrealist work of André Masson, Gorky,[6] and Joan Miró.[7] The early Abstract Expressionists shared the Surrealist preoccupation with Freud and the desire to express the subconscious mind in art. Like the others, Hofmann experimented with automatism—as did his students. Recalled former student Fritz Bultman, "automatism was part of the atmosphere that the Surrealists brought to New York after the fall of France, and the Hofmann School was a place where such ideas were aired, tried and discussed."[8]

The more significant early exchanges between Abstract Expressionist artists were visual rather than verbal and occurred during studio visits. One of the most complex and significant exchanges transpired between Hofmann and Pollock. Pollock saw Hofmann's *Red Trickle* of 1939[9] when Lee Krasner took him to Hofmann's studio in 1942.[10] Poured rivulets of paint began to appear in Pollock's work in 1943, particularly in *Composition with Pouring*.[11] Whether or not Hofmann was the primary influence on Pollock's use of poured paint (Pollock's involvement in David Alfaro Siqueiros's experimental studio probably contributed, and both Hofmann and Pollock were interested in processes employed by Masson), their work was close enough by their 1944 exhibitions to inspire Maude Riley, critic for *Art Digest*, to state in her review of Hofmann's first show at Art of This Century: "Jackson Pollock comes to mind at the first step within the Hofmann show." She continued to assert that Pollock was Hofmann's student.[12] Attempting to correct the error in a letter to Peyton Boswell, the editor of *Art Digest*, Hofmann made the significant statement that his approach was "fundamental[ly] diametrical[ly] opposed" to Pollock's: "We have in common only the same landlord . . . and the appreciation for a very good time and good painting."[13]

A famous and brief verbal exchange between Hofmann and Pollock symbolizes Hofmann's divergence from the Abstract Expressionists. On a visit to Pollock's studio, Hofmann commented with his peculiar cadence, "You are very talented, you should join my class." He looked at Pollock's palette. He picked up a brush and a whole can of paint came up with it, whereupon he said, "With zis you could kill a man!" After a few more exchanges, Hofmann said, "But you do not work from nature. This is no good. You will repeat yourself. You work by heart, not from nature." Pollock replied, "I *am* nature!"[14]

The story is usually told to imply the didacticism of Hofmann's insistence on working from nature. The alternative implication is rarely raised: he sensed that Pollock needed the stimulus of nature. Hofmann was not so much contending that Pollock needed more structure as responding to what he perceived to be a certain conceptual rigidity.[15] Hofmann himself worked from the model and landscape into the 1940s and from still lifes into the late 1950s.[16] Around 1959 he told a former student, "I have sketched for fifty years and now my mind is so full and I am able to remember what I need."[17]

Nature provided Hofmann with a constant source of volume and color, and he differed from the Abstract Expressionists all along in his exploration of both. Deeply

**6** Gorky's influence suggested to the author by Phillip Pavia in a telephone conversation on 29 July 1993; the influence can be seen in Hofmann's work in the early 1940s. Glenn Wessels wrote in a letter to Lois Stone, "To me he fully acknowledged the value of Arshile Gorky's pioneering." Wessels to Stone, 12 March 1975, Vaclav Vytlacil Papers, Bancroft Library, University of California, Berkeley.

**7** The influence of Miró recalled by former student Virginia Admiral, letter to Melvin P. Lader, 7 December 1975; and in taped conversation with the author, October 1992, New York. Hofmann denounced Salvador Dali to his students. Miró also had little use for Dalí and refused to be called a Surrealist (James Gahagan, conversation, 14 May 1993), as did André Breton. Peggy Guggenheim, *Confessions of an Art Addict* (London: André Deutsch, 1960), p. 88.

**8** Fritz Bultman, lecture at Parsons School of Design, New York, 11 December 1980. Typescript, estate of Fritz Bultman.

**9** Earl Pierce, transcript of taped monologue, August 1991, Berkeley, Calif. Also Erle Loran, "Hans Hofmann and His Work," *Artforum* 2, no. 11 (May 1964), p. 34.

**10** Hofmann's student Lee Krasner met Pollock in 1941 and in the next year or two introduced Pollock to Hofmann. After 1942 they were in close contact; their studios in New York were next door to each other, and in 1943 Pollock and Krasner visited the Hofmanns in Provincetown. Bultman, lecture at Parsons School.

**11** Pollock did not commit himself to the technique until late 1946 or early 1947. Elizabeth Frank, *Jackson Pollock* (New York: Abbeville Press, 1983), pp. 47, 63.

**12** Maude Riley, "Hans Hofmann: Teacher-Artist," *Art Digest* 18, no. 12 (15 March 1944), p. 13.

**13** Draft of letter from Hans Hofmann to Peyton Boswell, 16 March 1944. Estate of Renate Hofmann.

**14** Comment by Lee Krasner excerpted from *The New York School*, video written and narrated by Barbara Rose, copyright Michael Blackwood, WDR (West Germany), 1973. Museum of Television and Radio, New York, #T:22620. A similar version of the story is mentioned by Lee Krasner in her interview with Dorothy Seckler, 2 November 1964, p. 14. Typescript, Oral History, Archives of American Art, Smithsonian Institution, Washington, D.C.

affected by his experiences in Paris, he attempted throughout his life to unite the accomplishments of Cubist form and Fauve color.[18] Reminiscent of the phrase scrawled on Tintoretto's studio wall, "the drawing of Michelangelo and the colors of Titian,"[19] Hofmann commented to a student in 1952, "I want to synthesize the line of Picasso and the color of Matisse."[20]

Hofmann's thoughts on volume, "the line of Picasso," were influenced by the writing of Adolf Hildebrand, a Munich sculptor whose book *The Problem of Form in Painting and Sculpture* he encountered prior to World War I.[21] Around 1965 Hofmann wrote to a graduate student in art history: "Art education, art history and the artist have been merely ignorant about space as the predominant problem in the visual arts up to the appearance of Adolf Hildebrand's book." Hofmann felt that Hildebrand's concept of space was "an unactivated creatively nonparticipating passive space," which he opposed in the first pamphlet for his Munich school to what he later described as "a force impelled dynamic and vital ambiguous space." "Space is energy," Hofmann wrote in 1965. "Space is not emptiness but has volume like the object. Without energy there can be no space."[22]

In the beginnings of the modern movement in Paris, the importance of volume emerged with new urgency when the avant-garde rejected the use of linear perspective. Linear perspective, in Hofmann's words, gives the illusion that "there are holes or . . . things that spring out of the picture."[23] (He was quick to point out that even Leonardo, despite his legendary obsession with linear perspective, did not use it in his painting.[24])

**15** James Gahagan, interviews with the author, Woodbury, Vt., 30–31 March 1991.

**16** James Gahagan, conversation, 11 June 1993.

**17** Glenn Wessels, "Education of an Artist," oral history conducted in 1966 by Suzanne B. Riess. Regional Oral History Office, Bancroft Library, University of California, Berkeley, p. 146.

**18** Fritz Bultman, "The Achievement of Hans Hofmann," *Art News* 62, no. 5 (September 1963), p. 54.

**19** Reported by C. Ridolfi in *Delle maraviglie dell'arte,* cited in Robert Goldwater and Marco Treves, eds., *Artists on Art: from the XIV to the XX Century* (1945; New York: Pantheon Books, 1972), pp. 101–2.

**20** James Gahagan, interviews 1991, 1993.

**21** Adolf von Hildebrand, *The Problem of Form in Painting and Sculpture,* trans. Max Meyer and Robert Morris Ogden (New York: G. E. Stechert & Co., 1907). The writing of both von Hildebrand and the philosopher Konrad Fiedler was inspired by their friendship with the painter Hans von Marées, whose correspondence from Italy reflected his own struggle with the theoretical problems of painting. Konrad Fiedler's *Schriften über Kunst* was based on a combination of the experience of von Marées with the ideas of Immanuel Kant. (Hofmann admired the work of von Marées.) Hildebrand was greatly influenced by his discussions with Fiedler, who collaborated on the revision of *The Problem of Form.* Fiedler's own book was not published until twenty years after his death in 1914. The popularity of Hildebrand's book (essentially concerned with the problems of form and spatial unity particular to sculpture and bas-relief) was due to a general reaction against the Impressionist loss of form.

Dora Vallier, *Abstract Art,* trans. J. Griffin (New York: Orion Press, 1970), pp. 12–14, and Harry Francis Mallgrave and Eleftherios Ikonomou, introduction to *Empathy, Form and Space: Problems in German Aesthetics, 1873–1893* (Malibu, Calif: Getty Center, 1994), p. 35.

**22** Hans Hofmann, handwritten drafts of letter to one of Meyer Schapiro's graduate students, ca. 1965. Estate of Renate Hofmann. Meyer Schapiro was a leading art historian and intellectual in New York.

**23** Hans Hofmann, lectures 3–11, ca. 1938–41, and lectures 1938–39 (hereafter cited as lectures). Papers of Karl Knaths, Archives of American Art, roll 433, frame 1392.

**24** Ibid., roll 433, frame 1348. Hofmann credited Leonardo with the invention of linear perspective.

The expression of volume in Paul Cézanne's work electrified both the Cubists and the Fauves, for Cézanne used multiple perspectives to create an experience of volume without disturbing the flatness of the picture plane.[25] The picture plane is not the canvas surface but an illusionary surface created through the tension of shifting planes. Hofmann often compared the picture plane to a soft balloon[26] or a soft sausage: "when I press on the one end it swells on the other end."[27] Kandinsky discussed the picture plane in *Concerning the Spiritual in Art* and *Point and Line to Plane;*[28] Hofmann studied both books. Evolving the implications of Cézanne further, both Kandinsky and Piet Mondrian suggested that color, rightly used, could achieve an expansion of pictorial space.[29]

Fauve color was galvanized by the new and powerful influence of simultaneous color contrast,[30] as was earlier the work of Georges Seurat. Hofmann claimed, "It is I who made Delaunay aware of Seurat."[31] During his friendship with Hofmann, Robert Delaunay created his first colorful abstract series, *The Windows* (1912),[32] and came in contact with the Blaue Reiter and the American Synchromists.[33] While undoubtedly moved by the work of these colorists, Hofmann's later revolution in color can be attributed in part to his admiration for Goethe,[34] whose *Theory of Colours (Farbenlehre)* of 1810 appeared nearly thirty years before the French chemist Michel-Eugène Chevreul published his theory of simultaneous color contrast. Goethe, unlike Chevreul and the later physicists, explored the effects of color in terms of physiology and psychology.[35] Through intricate optical experiments he observed how color appeared to the eye, particularly the "color light" impressions created by the aftereffects of seeing color: "Every decided color does a certain violence to the eye, and forces the organ to opposition."[36]

**25** Robert Henry, interview with the author, 15 April 1991, New York.

**26** Hofmann, lectures, roll 433, frame 1344.

**27** Ibid., roll 433, frame 1352.

**28** Wassily Kandinsky, *Concerning the Spiritual in Art* (1914; New York: Dover Publications, 1977), p. 44, and *Point and Line to Plane,* discussion of "basic plane," pp. 115–46.

**29** Piet Mondrian, "New Plasticism in Painting," *De Stijl* (1917), in Hans L. C. Jaffe, *De Stijl* (New York: Abrams, n.d.), p. 57. Mondrian, who lived in Paris in 1910 at the same time as Hofmann, was very influenced by the Cubists, and his statement likely derives from his discussions with them. Although Mondrian and Hofmann lived in Paris and New York at the same times and had overlapping circles of friends, there is no evidence that they knew each other. Barbara Rose postulates, "It is certain that Hofmann knew Mondrian in New York, where both were active in events sponsored by the American Abstract Artists," which included a number of Hofmann students. Barbara Rose, "Hans Hofmann: From Expressionism to Abstraction," *Arts Magazine* 53, no. 3 (November 1978), p. 113. Hofmann wrote copious notes in the margins of Mondrian's "Plastic and Pure Plastic Art" in his copy of the publication *Circle* (London, 1937). Cynthia Goodman, *Hans Hofmann* (New York: Abbeville Press, 1986), p. 72.

**30** The farther apart colors are on the color wheel, the greater their contrast will be, the most intense contrast occurring between complementary colors 180 degrees apart. Simultaneous color contrasts were set forth in Chevreul's color wheel, a device now familiar to schoolchildren. Chevreul also graduated colors in lighter and darker tones. Michel-Eugène Chevreul was a chemist at the Gobelins tapestry works whose 1839 book, *De la loi du contraste simultané des couleurs, et de l'assortiment des objets colorés considéré d'après cette loi,* expanded by Charles Blanc (1867), was explained in layman's terms by the American physicist and painter Ogden Nicholas Rood (1879), translated into French in 1881 as *Théorie scientifique des couleurs* and widely read by artists. Ellen G. Landau, "The French Sources for Hans Hofmann's Ideas on the Dynamics of Color-Created Space," *Arts Magazine* 51, no. 2 (October 1976), p. 78; see also Herschel B. Chipp, "Orphism and Color Theory," *Art Bulletin* 40 (March 1958), pp. 57 n. 18 and 58 n. 27.

**31** William C. Seitz, *Hans Hofmann,* exh. cat. (New York: The Museum of Modern Art, 1963), p. 7.

**32** Their wives, meanwhile, collaborated on the design of Cubist hats for Sonia Delaunay's fashion shop. Hofmann and Delaunay later contributed fabric designs. Bultman, lecture at Hirshhorn Museum of Art, 1977, p. 7. Estate of Fritz Bultman. See also Pierce, taped monologue. Wight claims the artists were friendly when Hofmann worked in the studio on the quai des Grands-Augustins. Frederick S. Wight, *Hans Hofmann* (Berkeley: University of California Press, 1957), p. 29. Wessels stated they were studio mates. Wessels, oral history, p. 121. Also Wessels, "Tradition and Abstract Expressionism," lecture delivered at University Art Museum, University of California, Berkeley, 1964; and Wessels to Lawrence Dinnean, 13 March 1973, Hans Hofmann Papers, Bancroft Library, University of California, Berkeley. Sonia Terk (Madame Delaunay), a Russian, had studied in Germany, and she and Delaunay played an important role as a liaison between French and German painters. Wight, *Hans Hofmann,* p. 29. The Hofmanns may have met Sonia Delaunay through Wilhelm Uhde, the Paris dealer; she was Uhde's wife in 1908–9. She knew Hofmann well in those years but suggested that Robert did not know him until much later. Sonia Delaunay, interview with Gerald W. Adelmann, 14 January 1976, cited in Landau, "French Sources," pp. 78, 81 n. 8. Delaunay was in the army from 1907 to 1909. Typescript entitled "Lecture 14: Cubism: Gleizes and Metzinger," p. 9. Estate of Renate Hofmann. Therefore, the Hofmanns would not have met Delaunay until after he got out of the army and married Sonia in 1910.

**33** Delaunay was invited to show in the first Blaue Reiter exhibition in Munich in 1911 following a correspondence with Kandinsky initiated by a mutual friend, painter Elisabeth Epstein. Michel Hoog, *Robert Delaunay* (New York: Crown Publishers, 1976, p. 69). Other members of the Blaue Reiter (Paul Klee, Franz Marc, and August Macke) visited Delaunay in Paris in 1912 while he was working on the brilliantly colored *Windows* and *Discs* series. Chipp, "Orphism and Color Theory," pp. 55, 61.

**34** James Gahagan, conversation, June 1993.

**35** The difference in Goethe's approach mentioned by Chipp, "Orphism and Color Theory," p. 61 n. 45.

**36** Johann Wolfgang von Goethe, *Theory of Colours (Farbenlehre*, 1810) (Cambridge, Mass.: MIT Press, 1989), p. 25.

**37** Hofmann, "The Color Problem."

**38** Hofmann, quoted by Frank Crotty in "Expert in Abstract," *Worcester Sunday Telegram,* 18 November 1956, p. 29.

**39** Landau, "French Sources," p. 79.

**40** Chipp, "Orphism and Color Theory," pp. 55, 61. Also Pierce, taped monologue.

**41** Landau, "French Sources," p. 79.

**42** Kandinsky, *Concerning the Spiritual in Art,* pp. 19–20.

**43** Hofmann, lecture notes dated *1939/40.* Estate of Renate Hofmann.

**44** Preceded by the short-lived, more conservative Académie Matisse in Paris and the equally short-lived MUIM Institute established by Ernst Ludwig Kirchner and Max Pechstein in Berlin. The Bauhaus was later created in Weimar in 1919; André L'Hote's Académie Montparnasse in Paris in 1922; the Ozenfant School of Fine Arts in London in 1938.

**45** Wessels, oral history, pp. 120–21. Also Monica Haley, conversation with author, Point Richmond, Calif., 7 March 1993.

**46** Statement by Peter Ruthenberg, who interviewed many of the German students and exhibited their work. Translated by Eleanor Dickey and paraphrased by the author. In Peter Ruthenberg, *Vergessene Bilder: 8 Studenten der "Schule für Bildende Kunst, Hans Hofmann, München" (1915–1932),* exh. cat. (Berlin and Frankfurt: Peter Ruthenberg, 1986), p. 3.

**47** Ernst Stolz and Glenn Wessels, "On the Aims of Art," *Fortnightly* 1, no. 13 (26 February 1932), p. 7.

Hofmann often compared art to music and spoke of color in terms of scales: the red scale, the blue scale, and so on. "These are comparable to the tone scales in music. They can be played in Major or in Minor. Each color scale follows again a rhythm entirely its own."[37] "Abstract paintings," he said in 1956, "should have rhythm and continuity comparable to harmonies of music. Every line on a canvas has to have an answering line; every color, an answering color."[38] The analogy, dating back as far as Aristotle,[39] re-emerged in Paris among the avant-garde as they struggled to redefine the content of art. Hofmann was in Paris in 1912 when Guillaume Apollinaire christened František Kupka and Delaunay as Orphists, a name alluding to Orpheus, the god who entranced Pluto with his music.[40] Hofmann also encountered the analogy in the writings of Goethe[41] and Kandinsky.[42]

Hofmann later described the tumult of art movements in Europe before the war as "a wonderful confusion. No one really [knew] what ha[d] happened and what was to be expected to happen in the . . . future. Everything seemed to be contradictory. . . . This was the situation when I started my school."[43] The first school of modern art, the Hans Hofmann Schule für Bildende Kunst[44] began as a rehabilitation program for shell-shocked soldiers of World War I[45] and quickly became a catalyst in the creation of a new world in art. The school inspired in Munich the same amount of controversy in traditional academic circles that it was later to enjoy throughout its years in the United States. The Hofmann school was even then a thorn in the side of the establishment, a *revolutionäres Ärgernis* (revolutionary irritant), offending the conservatives and attracting young and rebellious German students.[46]

By the late 1920s, the school was an international success. The spirit of the school reflected Hofmann's memories of the spirit of Paris before the war. Students described the school as "composed of such diverse elements as Chinese, Swedish, Western and New York American, Turkish, Finnish, Armenian, Russian, English, Czech, Italian, French. . . . In his school one meets the daughter of Richard Harding Davis [the most famous of American war correspondents] and the son of the Shah of Baluchistan."[47] It could easily be said that throughout four decades, Hofmann's school was not a school but a movement. The school changed continuously in response to the needs and suggestions of students, who in turn acted as translators, studio monitors, and organizers. They translated Hofmann's writings, taught him English, organized summer sessions, designed and distributed brochures, brought Hofmann to America, and arranged exhibitions of his work.

After Hofmann moved to America, the difficulty of understanding his English actually became one of the strengths of the school. Commented a former student: "Whatever you learned, you learned visually."[48] Hofmann was said to be teaching Cubism, but he regarded Cubism as a way of seeing, not as a style. In his classes at the University of California, Berkeley, Hofmann paraphrased a line from a 1930 article by Picasso: "To understand Cubism is to many like trying to read a book in another language, and if you cannot read it, do not conclude that the language does not exist."[49] In their struggle toward a new visual language, students considered their drawings to be experiments. The oddly similar technique and appearance of these drawings resulted from continual erasing and shifting as students explored the spatial relationships of the planes in the model or still life. They worked in both abstract and representational modes, for the important issue was not whether the work was abstract or not, but whether the work functioned as a "plastic" entity.[50] Hofmann always encouraged the rebellious streak in his students, and the remarkable variety of their mature work confirms his success.

The flow of dialogue and activity between the school and the art world intensified in the 1950s as former Hofmann students organized or exhibited in some of the first cooperative galleries in New York.[51] Although students naturally congregated after their time at school, Hofmann himself encouraged their sense of community.[52] Former students leased studios in a low-rent area of New York City, later known as Tenth Street. Many of Hofmann's students became the "second generation" of abstract painters[53] as Tenth Street blossomed into the hub of the 1950s art world.

By the time the Abstract Expressionists emerged full force after the war, Hofmann was preoccupied with renewing his ties in Europe. In 1949 a major exhibition of his work at the Galerie Maeght took him to Paris, where he visited the studios of his old friends Picasso and Georges Braque. That summer he attended Forum 49, a series of panel discussions held in Gallery 200 in the art colony of Provincetown, an old fishing village on Cape Cod. Robert Motherwell and Adolph Gottlieb were two of the artist-speakers in a session on "French Art vs. U.S. Art Today." The session inspired Hofmann to coauthor a response with his former student and fellow painter Fritz Bultman suggesting that "the greatness of Paris" resulted from "an invitation of participation to the spirit," a humanist attitude America should continue to emulate. The statement, "Protest against Ostrich Politics in the Arts," reflects Goethe's belief that there is no patriotic art and no patriotic science—both can only be furthered by a free and universal interaction of contemporaries with constant reference to the learning of the past:[54] "The estate of the arts should never be narrowed to a national basis—particularly by the artists."[55] Hofmann's wife, Miz, backed up his words with action. The next year, she curated, also with Bultman, an international exhibition of contemporary French and American painters in Provincetown, which proved to be the most radical artist-organized gathering of contemporary art in America since the landmark 1913 Armory Show.[56] A recipro-

48 Pierce, taped monologue.

49 Christina Lillian, notes of Hofmann classes 1930–31, University of California, Berkeley. Hans Hofmann Papers, Bancroft Library, University of California, Berkeley, folder 1:53. Picasso's original statement: "The fact that Cubism remained for a long time misunderstood and even at present is not understood by many people, has no eventual importance and in no way excuses uninformed judgments as to its worth. Because I do not know German and because a German book is only so much black and white to me I do not conclude that the German language does not exist." "Picasso, a Letter on Art," *Creative Art* (June 1930), p. 385. Published earlier in *Ogoniok* (Soviet Union, 1926) and *Formes* (France; February 1930).

50 James Gahagan, conversations with author, Woodbury, Vt., 22 and 24 May 1993.

51 Irving Sandler, *The New York School: The Painters and Sculptors of the Fifties* (New York: Harper & Row, 1978), pp. 30, 32, 38, 41, 43 n. 4; also James Gahagan, conversation, May 1993.

52 Sandler, *The New York School*, p. 33.

53 "The more the genesis of Abstract Expressionism is studied, the more entrenched becomes Hofmann's pivotal role as the interpreter of early 20th-century revolutions in European modern art and the mentor to the second generation of Abstract Expressionists." Gwen Kinkead, "The Spectacular Fall and Rise of Hans Hofmann," *Art News* 79, no. 6 (Summer 1980), p. 90.

54 Paraphrase of handwritten note by Hans Hofmann in folder entitled "Forum 49." Estate of Renate Hofmann.

55 Flyer, Provincetown Art Association. Also typescript entitled "American Art Today" in folder marked "1949 Provincetown . . . ," Estate of Renate Hofmann. Later published in Paul Ellsworth, "Hans Hofmann, Reply to Questionnaire and Comments on a Recent Exhibition," *Arts and Architecture* 66, no. 11 (November 1949), pp. 22–28, 45–47.

56 Entitled "Post-Abstract Painting 1950, France and America." Jeanne Bultman, conversation with author, Provincetown, Mass., 15 July 1992. Pollock, George McNeil, Richard Pousette-Dart, Hans Hartung, Karl Knaths, Mark Rothko, Perle Fine, Robert Motherwell, André Lanskoy, Weldon Kees, Willem de Kooning, William Baziotes, Nicolas de Staël, Adolph Gottlieb, Hofmann, Bultman, Giorgio Cavallon, Ad Rein-

hardt, Barnett Newman, Bradley Walker Tomlin, Jean Bazaine, Melville or Blanche Price, Hedda Sterne, Theodoros Stamos, Charles Lapicque, and Charles Hawthorne; sculptors David Smith, Herbert Ferber, David Hare, Seymour Lipton, Peter Grippe, and Ibram Lassaw. Provincetown Art Association, 6 August–4 September 1950 (flyer, Provincetown Art Association). Hofmann gave a lecture during the show at the Provincetown Art Association, 28 August 1950. Typescript, Estate of Renate Hofmann.

**57** Entitled "Réalités Nouvelles," summer 1950. April Kingsley, *The Turning Point* (New York: Simon and Schuster, 1992), pp. 261–63, 394 n. 9.

**58** The proceedings of the conference, as edited by Robert Motherwell and Bernard Karpel, are published in *Modern Artists in America* (New York: Wittenborn Schultz, 1951).

**59** Although he was not an active member of the Club, he did give a talk in the early years and always considered himself a member. James Gahagan, recounting conversations with Hofmann, note to author, 23 May 1994.

**60** Dorothy Seckler noted that the Abstract Expressionists visiting Provincetown, from 1943 on, became part of Hofmann's circle: Pollock and Krasner in 1943–44, Gottlieb and Baziotes between 1944 and 1958, Kline in 1957 until 1962, Rothko in 1958, and long-term residents Jack Tworkov, Motherwell, and McNeil. Dorothy Gees Seckler, *Provincetown Painters, 1890s–1970s,* exh. cat. (Syracuse, N.Y.: Everson Museum of Art, 1977), pp. 74–80.

**61** Noted Walter Darby Bannard, "he clustered extreme lights and darks before Still, poured and spattered before Pollock and painted classic Abstract Expressionist pictures in primary colors before De Kooning." Bannard, *Hans Hofmann: A Retrospective Exhibition,* exh. cat. (Houston: The Museum of Fine Arts, 1976), pp. 10, 11.

**62** Walter Darby Bannard commented, "Incidentally, it is interesting how many of our best painters are more 'on' to Hofmann than the rest of the art public." Ibid., p. 22.

**63** Rose, "From Expressionism to Abstraction," p. 110.

cal show including some of the same American artists was held that summer at the Palais des Beaux-Arts de la Ville de Paris.[57]

The affinities with the School of Paris that led to Hofmann's popularity in the 1930s worked against him once the major Abstract Expressionist painters rejected European influence. He was also older than the other Abstract Expressionists. He was not a heavy drinker and so was not a regular at their watering hole, the Cedar Bar. Due to his hearing problems, he had difficulty participating in their forums, such as Studio 35 in New York, a three-day symposium of leading artists in 1950,[58] and panel discussions at the Eighth Street Club, a center for informal artist gatherings and discussions.[59] Yet Hofmann remained in the center of activity. Other Abstract Expressionists joined the informal milieu that gathered around him in New York and Provincetown.[60] His statements were occasionally published in *It Is,* a magazine launched by Phillip Pavia in the 1960s as an extension of the Club.

Hofmann's technical innovations preceded the emergence of the Abstract Expressionists, and the flowering of his mature work occurred after the beginning of their decline.[61] He outlived Gorky, Pollock, Bradley Walker Tomlin, and Franz Kline, dedicating his 1962 *Memoria in Aeterne* to the memory of those four and one other: Arthur Carles, whom he greatly admired.

This exhibition represents the great outburst of energy of his last years. Hofmann ceased teaching in 1958 in order to devote all his time to painting. Thereafter followed a greater degree of recognition. His work was exhibited in Europe and the Americas. Major American magazines reported regularly on the success of his students. He arranged for the permanent preservation and exhibition of his work at the University of California at Berkeley, the first such agreement between a living artist and a cultural institution. Three American institutions awarded him honorary degrees (Dartmouth College, the University of California at Berkeley, and Pratt Institute). The Akademie der Bildenden Künste in Nuremberg offered him an honorable membership in 1962, and in 1964 he became a member of the National Institute of Arts and Letters in New York.

The extent of his recognition must have stirred him deeply, for it is difficult to comprehend the degree to which he was maligned during his life. Hofmann was a maverick, a true "painter's painter"[62] in the tradition of Cézanne and, like Cézanne, often regarded with derision. His assurance and enthusiasm, his thick accent and individual mixture of German, French, and English inspired fond caricatures among his students. His speech was so peppered with *nicht wahr* (isn't that so?) that it became his nickname. More established elements of the art world were less charitable. As far as the public was concerned, his character did not fit the image of the American painter—he was not inarticulate, his life did not present an aura of romantic angst, nor did he have a sudden breakthrough into a personal style.[63] He was additionally cursed by the old adage, "Those who can't paint, teach."

Just as his success was beginning to sink in, his wife of nearly forty years, Miz, died suddenly in April 1963, shortly after the arrangements were finalized for a large solo show at the Museum of Modern Art that fall. Hofmann was devastated by her death, yet surprised all those who knew him by traveling the next year to Puerto Rico with Renate Schmitz, a recent German arrival. At the age of eighty-five, Hofmann married Renate, a young woman of thirty-four, four months before his death in early 1966.[64]

The late paintings reflect this combination of tragedy and delight. The immensity of his grief for Miz inspired, in a great pendulum swing, the energy of his joyful final works, the *Renate* series. Hofmann himself explained the radiance of *To Miz: Pax Vobiscum* (To Miz: Peace Be with You), painted in 1964 a year after her death, as an expression of his "negative ecstasy."[65] Negative or positive, ecstasy prevails in the *Renate* series of 1965. Seven of the eleven paintings[66] in the *Renate* series appear here: *Profound Longing, Deep within the Ravine, Little Cherry, Summer, Legends of Distant Past Days, Nulli Secundus,* and *Art like Love Is Dedication.*

Hans Hofmann said in 1966, "In me develops a relationship to my own paintings, and this is mostly a poetic relationship, because what my paintings say is poetry. I consider this poetry expressed in color."[67] *Jardin d'Amour, Deep within the Ravine, In the Wake of the Hurricane, Prelude of Spring,* and *Ocean* all suggest, through color and title, their poetic reference to nature. The luxurious foliage of *Jardin d'Amour* appears again in *Rhapsody,* elevated beyond literal associations by the juxtaposed rectangles, floating in a garden as would a song. *In the Wake of the Hurricane* refers to the turbulent debris of dying plants and trees. "I am still a naturalist," Hofmann wrote, "my work symbolizes spatial constellations, the rhythm of which has to me a deep psychological—a deep mystic and poetic meaning."[68] *Towering Clouds* and *The Conjurer* show similar shapes in a similar array of colors, yet the disparate rhythms of their spatial constellations create entirely different meanings in each work. *Towering Clouds* expresses the roiling of storm clouds and the rich colors of a summer landscape, while the density of mood in *The Conjurer* does not bring the lightness of clouds to mind.

In contrast to the density of *The Conjurer,* the rhythms of *Magnum Opus* are simple and spacious. The real challenge of nature, to Hofmann, was not to portray objective reality but to re-create a similar sense of relationship: "Nature is always the artist's best source of inspiration, but in its spiritual, not physical sense. In nature every object, every living thing exists in relationship to other things. This is the integration we must seek in art."[69]

The single yellow of *Magnum Opus* plays against a complex of blues and greens, compact relationships that intensify the expansion of the reds and pinks above. The groups of colors in *Magnum Opus* are what Hofmann would call color complexes: "The characteristic of every great work of art is simplicity. In its final state, the color development over the whole picture surface leads to the creation of color—or light—complexes. The composition is thereby dominated by a few such complexes only."[70]

**64** Marriage certificate, State of Pennsylvania, dated 14 October 1965. Estate of Renate Hofmann.

**65** Goodman, *Hans Hofmann,* p. 96.

**66** Hofmann intended to keep the series together. Eight are now on extended loan to the Metropolitan Museum of Art, with one in the permanent collection. Ibid., p. 97.

**67** Hofmann, interview with Irma Jaffe, 13 January 1966, p. 10 (hereafter cited as Jaffe interview). Oral History, Archives of American Art.

**68** Hofmann, typescript entitled "An Answer to a Question," n.d. Estate of Renate Hofmann.

**69** Hofmann, quoted by Frank Crotty in "Expert in Abstract," *Worcester Sunday Telegram,* 18 November 1956, p. 29.

**70** Hofmann, "The Color Problem in Pure Painting—Its Creative Origin" (hereafter cited as "The Color Problem"). First published in *Hans Hofmann: New Paintings,* exh. cat. (New York: Kootz Gallery, 1955). Reprinted in Wight, *Hans Hofmann,* p. 54, and Sam Hunter, *Hans Hofmann* (New York: Harry N. Abrams, 1963), pp. 46-48.

"In nature," Hofmann said, "light creates color. In a picture, color creates light."[71] The uncompromised yellow in *Magnum Opus*, perhaps a poetic symbol of a solo masterwork, also brings to mind how Matisse compared the effects of color to the striking of a gong: "A blue . . . accompanied by the shimmer of its complementaries, acts upon the feelings like a sharp blow on a gong. The same with red and yellow; and the artist must be able to sound them when he needs to."[72] In this sense, the distinct notes of color in *Summer,* and their aftereffects, could play an entire rhapsody.

Hofmann envisioned color complexes as "a multitude of color vibrations" refracting through the painting as color light refracts in a jewel, building what he called a sense of "translucency." This phenomenon is particularly visible in *Legends of Distant Past Days, Lumen Naturale,* and *Combinable Wall I and II.* All resemble Hofmann's description of a painting by Pierre-Auguste Renoir:

"[S]uch a picture has not a surface life—it has an inner life; slowly it comes back to the surface, closes into an enormous volume. This volume [t]hat has an enormous quality, [t]hat reflects—brings light in and pushes light out. . . . Only the really great painting has a quality like the light . . . [i]n a diamond. . . . A great painting has the light inside so that it may come out again to us."[73]

As Hofmann responded to the spatial constellations of color on canvas, poetic associations emerged. He described this process in 1960: "My work is not accidental and is not planned. The first red spot on a white canvas may at once suggest to me the meaning of 'morning redness' and from there on I dream further with my color."[74] The redness of the painting that became *Pompeii* must have suggested the expansion of red-hot lava, made all the more possible by the lack of resistance in the lower blue. The red rectangle of *Profound Longing* has just the opposite effect. It shrinks into the beyond in an aching expression of emptiness that seems to pale the surrounding shades of green.

A similar interplay of expanding and contracting forces can be seen clearly in *Goliath,* where contracting forms in the lower half are dwarfed by those hovering above—and yet simultaneously enhance their dispersion. "Forces and counterforces produce movement," Hofmann observed, "with rhythm and counter-rhythm as their logical consequence."[75]

The quality of these rhythmic relationships determines the quality of the work. In nature the eye seeks variations of light; in a painting, the senses seek variations of rhythm. Hofmann told his students, "If rhythm has all the same intensity, it's not vital enough."[76] In *Imperium in Imperio,* the lighthearted strokes hidden within the center play against the slow, powerful tilt of the form above. Compare the tempo of implied oscillations of color planes in *Equinox, Combinable Wall I and II,* and *Lumen Naturale* with the swift meanderings of *Wind.*

Tensioned relationships can occur within a form or between the form and the four edges of the canvas, giving a single form a sense of volume and motion. The weight and stillness of the black form in *The Vanquished* contrast with the buoyancy of

**71** Hofmann, speech delivered at the inauguration of the Hopkins Center (hereafter cited as Inauguration speech), Dartmouth College, Hanover, N.H., 17 November 1962, p. 5. Estate of Renate Hofmann.

**72** Henri Matisse, from "The Chapel of the Rosary," in *Matisse on Art,* ed. Jack D. Flam (New York: Dutton, 1978), p. 128.

**73** Hofmann, lectures, roll 433, frame 1345.

**74** Hofmann, interview with Katherine Kuh, *The Artist's Voice: Talks with Seventeen Artists* (New York: Harper & Row, 1960), p. 125.

**75** Inauguration speech, p. 5.

**76** Nieves Billmyer, notes from Hofmann classes, ca. 1940s, read aloud in interview with author, 28 December 1991, New York.

*Little Cherry.* The flat shapes of *The Vendetta* become the expanding, roiling chaos of battle.

These tensioned relationships create "plasticity,"[77] or what Hofmann called "push and pull": a simultaneous movement in and out of depth. A form appears to move out in relation to one area and back in relation to another.

"Push and pull are a visual sensation created by the mind either through the experience of tensions in nature or through the creation of tensions on the picture surface . . . a vivid tension-controlled and force-impelled sensation of suggested movement 'in and out' of depth is created, without [destroying] the two-dimensionality of the picture surface."[78]

Despite the analytic tone of Hofmann's statements, his concerns were transmuted into visual and emotional instinct as he painted. "Let me confess: I hold my mind and my work free from any association foreign to the act of painting. I am thoroughly inspired and agitated by the actions themselves which the development of the painting continuously requires. From the beginning, this puts me in a positive mood, which I must persistently follow until the picture has found realization through paint."[79] The facture (the making) of his paintings, like the facture of works by Rembrandt, Cézanne, and other artists he admired, resulted from this visual and instinctive process. "Technique is always the consequence of the dominating concept: with the change of concept, technique will change."[80] More heavily worked paintings reveal his struggle with the rhythms and relationships, while thinly painted works arrive suddenly, spontaneously, particularly works in the vein of *Maiden Dance* and *The Castle.*[81]

Yet the thin washes of *Agrigento* also represent Hofmann's response to the stain or wash technique then coming into vogue. He exhibited three such wash paintings together in 1962. He explained to a former student at the opening, "I've painted them and I'm exhibiting them to show how it should be done." Although he used the technique earlier, he had never used thin washes as a monochromatic composition. The varying transparencies of paint play in blocks against the white canvas to create a sense of volumetric structure. This small series led to the juxtaposition of rectangles and large washes in *Magnum Opus* and *Polyhymnia.*[82] Hofmann, always intrigued by the work of his peers, had a tendency to explore their turf. His dialogue with the stain painters was preceded by visual dialogues with students and Abstract Expressionists, with Arthur Carles, Gorky, Matisse, Picasso, Cézanne, Seurat, Kandinsky, and many others.

As a result of his continual exploration, some works in this exhibition do not appear to be by the hand of the same painter, particularly the more figurative *Gilotin,* a mysteriously cheerful character belying what may be a grim reference in the title. The spiraling nature of Hofmann's development and his continuing conversation with his past work are well illustrated by the inclusion of this piece. Similarly rounded, simplistic figures appear in self-portraits throughout the 1940s and 1950s, yet without the thick impasto, here reminiscent of 1930s still lifes.

**77** In 1917 Mondrian used the term *plasticity* to describe the three-into-two-dimensional problem of painting. The term *plastic* is a fundamental expression with regard to art in both French and German. The French *plastique* and the German noun *Plastik* or adjective *plastische* (and, incidentally, the Spanish *plastico*) relate to the sculptural qualities of form.

**78** Inauguration speech, p. 6.

**79** Ibid., p. 7.

**80** Hofmann to Elaine de Kooning, "Hans Hofmann Paints a Picture," *Art News* 48, no. 10 (February 1950), p. 38.

**81** Gahagan, conversation, 24 May 1993. The paintings are in the collection of the Berkeley Art Museum, University of California.

**82** Ibid.

Hofmann's own cyclical patterns correspond to his view of the development of art itself. Thus he wrote in 1952: "There is in reality no such thing as modern art. Art is carried on up and down in immense cycles through centuries and civilizations."[83] "What I would hate most is to repeat myself over and over again—to develop a false style. I do not want to avoid immersing myself in trouble—to be in a mess—to struggle out of it. I want to invent, to discover, to imagine, to speculate, to improvise—to seize the hazardous in order to be inspired. I want to experience the manifestation of the absolute—the manifestation of the unexpected in an extreme and unique relation. I know that only by following my creative instincts in an act of creative destruction will I be able to find it."[84]

**83** Hofmann, "A Statement by Hans Hofmann," *Hans Hofmann: Recent Paintings,* exh. cat. (New York: Kootz Gallery, 1952).
**84** Hofmann, corrected typescript draft of untitled article, dated April 1950, beginning, "When I start to paint," p. 1. Estate of Renate Hofmann.

# Texts by Hans Hofmann, 1951–1963

## Statement, 1951

### The object in the visual arts—its function in three-dimensional reality and its two-dimensional pictorial realization.

Cézanne has said once: it has taken him forty years to discover that painting is not sculpture. One may still say today that modern art has not yet digested the fundamental problems of pictorial creation in its entirety. All attempts so far to go unrestrictedly to the roots of the problem have yielded only sophisticated fragmentations, each one of them on a very high esthetical level. This fragmentation characterizes our entire time. We put tens of thousands of mechanical parts together to create living mechanical wonders. The multi-expression of modern art confirms only the immensity of all the problems involved in pictorial creation. It is understandable that in earlier times the great discovery of the old masters has been buried in the convents in great secret. The Twentieth Century Artist *does the opposite*—he has used the broom of good reasoning to liberate the arts of all the coagulated wisdom of the Academy. It started with the dethroning of the object by the Impressionists. The tyranny of its synthesis has obscured and tortured the minds of centuries. Considered only as what it really is—it lost its significance of being itself a creator of highest order solely in its reflection of its environment. It must be categorically emphasized: the object is a creator itself. Beside its characteristic and its psychological function, it enlivens space—it creates all *its rhythmic wonder and (in total) the unbelievable beauty of space.* Space lives from the object which is space . . . just as every form of life lives from life. In recognizing its creative function the modern artist by no means destroys the object, but on the contrary sublimates it through subordination and integration into the higher form—of a compositoric entity given by *the esthetic form in which every genuine work exists.* The object can never create a work of art without the demand of such a higher sublimation, whereas an esthetic form can exist without any object solely through the animation of the pictorial means. This is the reason for non-objective art. It is primarily the animation of the pictorial means—not the animation of the object—*that leads into pictorial over-all animation.* The pictorial realization and animation of an object will result from a step by step development of such an over-all animation, wherein the final plastic and psychological realization of the object represents the logical *finale* of the creation.

We differentiate today between form in a biological sense, which concerns the object, and between form in an esthetic sense, in which the work exists spiritually as a work of art. The first concerns the physical logic of the object—the other is a form which is exclusively created by the mind. The merging of both is documented in all the great works of the old masters. Only Matisse, Picasso, and Braque, each of them in his own way, and a few others have mastered this mammoth problem.

It is still not yet generally recognized that the picture surface answers the animation of a plastic impulse automatically with a plastic counter-impulse. That means the automatic reaction of the picture surface of pictorial animation is dominated by inherent laws which *respond* plastically with highest precision to such animation. It is for this reason possible to generate forces on such a surface which respond to each other not only with greatest exactitude in the sense of push and pull, but furthermore and with the same exactitude in the sense of intensity and speed with which to vary depth penetration as well as its answering counter-echo. *Only from the varied counterplay of push and pull and from its variation in intensities will plastic creation result.* Let us repeat that the object is a space-creator. Considered as such, it is a source of highest inspiration for plastic creation. But to be of use for pictorial animation the object, or in short, the model must be broken down into spatial fragments. These fragments must be further considered in their function not only in relation to the object, but predominantly in relation to the spatial totality in the frame of which the object is only a subordinated part. It is therefore not a consciousness of the synthesis of the object that should primarily dominate the creation, *but a consciousness of the synthesis of the spatial totality* should consider the object as an integrated part of it. It is out of the pictorial realization of spatial totality that the image of the object should finally "emerge." It should be the confirmation as the "finale" of the creation.

In breaking down the spatial totality into spatial fragments this fragmentation assimilates itself with the pictorial means: points and lines and planes a.s.o., to serve pictorial necessities in the creation of pure plastic form which is given only *through identity of form and content.* Spatial synthesis is *a priori* given in the picture surface—its synthesis should never be broken throughout the whole pictorial development, but its synthesis can be transformed by subdivision into the infinite. The beauty of space is finally presented *in the rhythmic relation* of all parts involved within the meaning of its pictorial functions. It is only through step by step development that the transfiguration of plastic experience into the plastic realisation on the picture surface takes hold. Simplification of spatial totality under consideration of the Essentual and Elimination of the unessential—an art in itself—leads to abstraction. Objective consideration must be subordinated.

Plastic creation asks for feeling into the essentuality of nature as well as for feeling into the essentuality of the nature of the medium of expression. The plastic experience gained by the former must be transformed into the plastic language of the other. Nature cannot be copied. A continued counter-balancing from one feeling-

aspect into another determines the quality of the work. *It involves the whole sensitivity and the temperament of the artist.*

The foregoing findings deal only with the formal problems of composition. Painting involves color—but the color problem is also to a great extent a formal problem, in the way in which color is placed on the picture plane. Color has the faculty to create volume and luminosity. Volume is a dimension—a dimension in and out of depth. Every difference in color shade produces a difference of speed in depth penetration. In hand with it goes its luminosity, which is not so much presented in the color shades as in the relation of corresponding color shades: corresponding either by contrast or harmony and through differences of intensity or by dissonancy as simultaneous rendering. Colors correspond in the form of intervals: in seconds, thirds, fourths, fifths, a.s.o., as music does. This faculty makes color a plastic means of first order. The way that colors are related can create drama, poetry, lust, pain, pleasure, ache a.s.o. Color development follows its own laws. The color development is not necessarily the same as the formal development. Independent as it is, it overlaps however perfectly with the formal development of the composition. Objective presentation arrives finally exclusively only from the color development. And it is not form, in the sense of the physical logic of the object, that determines the development of color, but it is on the contrary the color development under consideration of pictorial laws that determines integrated objective form. This is painting! Objective form and also esthetic form *not* arrived at through the fire and blood of the color—or not arrived at through the demand of integration, is only design. It is decor and ornamentation and belongs, as such, in the realm of applied art—not painting.

Typescript, New York, 1 May 1951, estate of the artist

## Statement, 1951

### Space pictorially realized through the intrinsic faculty of the colors to express volume.

Only a plastic statement on the picture surface that has resulted from a strictly spatial experience from nature, and from the automatic response of the picture surface in answer to its plastic animation, can be considered "absolute" in the sense that it will permit the use of unbroken pure colors. This binds the colors from the beginning to a formal problem, in the way in which color is compositionally placed and formally measured on the canvas by shading and size.

A pure color can be any mixture of color as long as such a mixture is handled flat and unbroken, so that the totality of its formal extension offers only one color shade and with it only one light-meaning. By this I mean, as long as the area that is

given to the color or the shape in which the color exists is not shaded down in a multitude of different light values as the Impressionists did. (This dissolves the areas or the shapes.) By relation with other colors, the aspect of such a pure color mixture becomes translucent by suggesting depth penetration and with it volume of varied degree. The suggested volume will be the exact plastic equivalent that the color is intended to present, to counteract its formal placement in the necessary compositoric attempt to re-establish two-dimensionality. *In other words any color shade must be in the volume that it suggested, the exact plastic equivalent of its formal placement within the composition.* The depth meaning (volume suggestion) inherent in any color shade is therefore in direct dependency from its compositoric placement. The impressionistic method leads into a complete splitting and dissolution of all areas involved in the composition, and color is used to create an overall effect of light. The color is, through such a shading down from the highest light [to] the deepest shadows, sacrificed and degraded to a black-and-white function. This leads to the destruction of color as color. To understand this, one must be clear that any light value can be brought to expression through thousands of different color shades. Such a handling of colors leads to an overall effect, but to an overall effect that destroys the *intervalle* and contrast-faculty of the colors. The *intervalle* faculty makes the color a plastic means of first order. The consequence in the lack of such a conception is that all pictures handled in this way present themselves in a similar overall tonality. It was Cézanne who said at the end of his long search for pictorial truth: "All lies in the contrast." He obviously meant to say, as far as color is concerned: "The finest color shades offer powerful contrasts." We find his statement documented: in the Icons, in Cimabue, in Giotto and in Fra Angelico—in Matisse and in Miró and in all work where color is understood in the psychological rapport and *intervalle* capacity which they offer.

The effect of this capacity is mystic. *Mystic expression in the plastic arts stems mainly from the psychological rapport capacity of the colors.* The mystic quality of the colors will come, however, to appearance only in relation to a strict mastery of the colors within the composition through the placement of the colors.—It concerns predominantly the formal handling of the color. Color must not be enslaved into a function foreign to its intrinsic faculties.—When mutually related, everything makes its mark on another thing. So do colors. They influence each other considerably in a psychological sense, as shapes do.—A different color shade gives the same shape another psychological meaning. Difference in plastic or spatial placement (composition) causes any color or shape or color-shape to change completely in psychological expression.

This explains the magic of painting.

Statement in *New Paintings by Hans Hofmann*, exh. cat. (New York: Kootz Gallery, 1951)

## Statement, 1952

I develop two styles in painting. Neither, however, differs conceptionally from the other; they differ in approach and technicalities.

An artist's concept is basically given in his whole outlook to the world and in the consciousness of his professional responsibilities. The subject has only an initiating function to be restless, absorbed by the personality of the artist—as such it will determine the whole creative process.

I have devoted my whole life to the search of the Real in painting. I never believed in an academic training—I had none. My instinct told me that I must find everything within myself when it is intended to become significant for the whole spread of my own development. I was privileged to be brought up in a highly artistic environment. I love beautiful things not for want's sake—but they inspire me to create them myself. To me they have the capacity of emanating a mystery power that is able to hold the mind under the spell of ecstasy.

Art is to me the glorification of the human spirit and as such it is the cultural documentation of the time in which it is produced. The deeper sense of all art is obviously to hold the human spirit in a state of eternal rejuvenescence in answer to an ever-changing world. Art is an agent destined to counter-balance the burdensomeness of everyday life—it should provide constant esthetic enjoyment.

I still make the difference between Fine and Applied Art and between art in general. The difference is revealed in the creation of quality through which the created image becomes self-evident. Quality results in every instance from a creative act. I make further the distinction between easel and mural painting. Easel painting is to me a symphonic art; the mural is predominantly a decorative art and asks for simplification (but it must not deteriorate into a poster-art).

There is a difference between "decorative" and "decoration." Decoration is based on design. Design in the usual sense results from taste only. *Taste is not a creative faculty*. The function of design is ornamentation. As such it is either art or it is not. When it is art it offers quality; when it is not art—it does not. To be truly decorative presumes the *faculty of plastic and esthetic creativeness*. A decorative work is basically always a plastic work of art. It is *de facto* two-dimensional but in "suggestion" three-dimensional; in other words it is *eo-ipso*—three-dimensional in concept and *de facto* two-dimensional in execution. Design that does not result from plastic and esthetic experience will only produce empty flatness—especially when it is further devoid of some other spirited revelation. This is then bad design. There is good and there is bad design. Good design has a life of its own. Bad design is lifeless and monotonous. By strictly limiting the meaning of the word design to its *de facto* meaning we are further induced to make a strict and sharp differentiation between design and plastic creation.

Mural and easel painting must be, further, differently approached as far as color is concerned. In a mural, color is to be simplified to its decorative purpose. A too rich

overcast in tonal transition would destroy the attempted decorative effect. It would destroy the contrast faculties of the color. In a mural, color should be handled flat over huge expanded areas in a simultaneous way by which the picture surface will be kept in a constant pictorial balance. This will occur when colors answer each other in the combine of their plastic and psychological rapport capacity which they offer. This emanating capacity of the color depends a great deal on the formal placement of the colors within the composition, and from the creation of varied intervals that makes the color a plastic means of first order. The easel painting asks for greater intimacy. It is in character more lyrical and it asks therefore for a richer orchestration. Basically it must be flat like the mural. But the flatness must become the expression of volume—it must be the end-product of an immense accumulation of intrinsic values which have conditioned each other esthetically in a step-by-step development to summarize finally in the creation of this all-dominating singular luminous and translucent volume that is to make the spatial totality and monumentality of the picture. Only this I consider "cultivated" painting.

I have said that I develop two styles—a decorative one and a highly symphonic one. Besides these, I work as I please, by heart or from Nature. My sense of independence does not permit me to commit myself to any retarded or advanced method. There is in reality no such thing as modern art. Art is carried on up and down in immense cycles through centuries and civilizations. No choice is given us. Goethe says *"the wave that lifts us will finally swallow us."* It is our destination and the destination of every culture.

Statement in *Hans Hofmann: Recent Paintings*, exh. cat. (New York: Kootz Gallery, 1952)

## Statement, 1956

### The creative process: its physical and metaphysical performing.

In my own way of search as artist, the universe seems to be a will-directed magnetic entity with all life embedded in it. It is, figuratively speaking, a vast ocean that holds the sum total of all energy and the potentiality of all forces. The sum total being gravity. Forces come into being through compensation arrived at by level—intensity—and tensional differentiation either toward a static magnetic overall level or through compensation by existing level—or other differentiation within the inherent nature in a given medium. The compensation becomes in this way the *"dynamic source of all"* free energy. Free energy may condensate either into substance by expansion or contraction or in time-and-space, demanding movement and rhythm. Viewed in this way "time and space" are both either *"consumed" energy (in the past)* or *"consume-demanding" energy (in the future)*. Past and *future* keeps the cosmos in a constant but balanced state of expansion and contraction. Still we do not yet know

the origin that initiated the impulse and its self-sustaining and reproductive capacity that is life . . . how the phenomena of flesh and blood came to be, or a thinking and sensing mind. We know only the creative physical facts whereby a positive produces a negative—a high a low, a right a left—a push a pull and vice versa. All optical phenomena are the result of complementary compensation. Here we seem to be given an analogy between the universal laws and our creative mind. Our creative capacity sees itself mirrored in these laws. We are actively interwoven in it and so are our creative means. A picture is in the same way a universe—it holds its own life and mirrors a mind and a soul. Within all these laws seem[s] to be a directing will and we are also directed by this will—this will is the urge to create—it is a cosmic will that determines all creation.

Typescript, 12 January 1956, estate of the artist

## Statement, 1956

### A reply to the demand to name some of my students who have come into prominence.

I never have considered myself the founder of a particular school. I am not a teacher in the usual sense. I am a painter who had to teach for his livelihood to assure artistic independence. In this function I became the initiator and disseminator of certain creative ideas that have contributed to the cultural evolution of our time. My very inmost thoughts hold in my opinion the key to many schools—past, present and of the future. I enjoy the wrong reputation that I love to teach. What I love really in the function as a teacher is the steady contact with new possibilities in the future—with new generations. Because teaching is not really a vocation on my part, I made teaching the greatest pleasure for myself by giving myself completely as artist and human being determined to investigate and to clarify the mysteries of the creative process. It never makes any difference to me if a work brought before me is of greater or minor quality; it offers always the substance on which to demonstrate the creative process and this under consideration of individuality and temperament. This seemingly heterogeneous professional attitude has built up my reputation as artist and teacher. I have students all over the world—many thousands of them who have become ambassadors for the spread of my basic ideas, and every one of them is doing it in his own individual way. This makes it impossible for me to name any one person—it would not be ethical. No one can make an artist and I do not claim the "qualité d'auteur" for any one of them. . . .

Typescript, 25 January 1956, estate of the artist

98

**Statement, 1963**

**The way we see: analysis of eyesight in relation
to physical experience of nature.**

Analysis of eyesight goes hand in hand with our visual relation to nature. We must therefore understand nature's function in regard to visual experience.

Nature surrounds us unlimited in every direction. We may proudly consider ourselves as her middle point—the middle point of unlimited space.

Unlimited space is three-dimensional. Appearance is two-dimensional.

We have, however, learned through experiences of all our other senses to interpret appearance as a three-dimensional Reality. Nature has equipped us with eyes which have a horizontal common axis and everything we see has a related and very distinct movement to it.

This axis is constantly on our mind and acts magnet-like in respect to plastic analysis of vision. Our eye axis is also identical with the horizontal axis of appearance and with the horizontal axis of the picture plane.

Everything in the outer world is related to it in position, movement, rhythm, depth projection, color, light, etc.

The relation of unlimited Reality and all that she visually offers in relation to our eye axis is the reason for coming into being of a visual phenomenon which I call Push and Pull.

Push and Pull is a colloquial expression applied for movement experienced in nature or created on the picture surface to detect the counterplay of movement in and out of the depth. Depth perception in nature and depth creation on the picture-surface is the crucial problem in pictorial creation. Nature as well as the picture plane have each its own intrinsic laws which are dissimilar but do in fact *not* refuse to compensate each other when handled by a creative mind.

"The Painter and His Problems: A Manual Dedicated to Painting," 1963, typescript, estate of the artist

# Chronology

**1880**

Hans Hofmann is born in Weissenburg, Bavaria, on 21 March, the son of Theodor and Franziska Hofmann.

**1886**

The family moves to Munich, where Theodor becomes a government official. Hans studies mathematics, science, and music at the gymnasium. He plays the violin, piano, and organ and begins to draw.

**1896**

With his father's help, finds a position as assistant to the director of public works of the State of Bavaria. Develops his technical knowledge of mathematics, resulting in several scientific inventions, including an electromagnetic comptometer.

**1898**

Studies painting with Willi Schwarz at Moritz Heymann's art school in Munich, where he is introduced to Impressionism.

**1900**

Meets Maria ("Miz") Wolfegg, his future wife.

**1903**

Through Willi Schwarz, he meets the nephew of a Berlin collector, Philipp Freudenberg, who becomes his patron from 1904 to 1914 and enables him to live in Paris.

**1904**

Frequents the Café du Dôme, a haunt of artists and writers, with Jules Pascin, a friend from Moritz Heymann's school. Miz joins him in Paris. Attends evening sketch class at the Académie de la Grand Chaumière and the Académie Colarossi. Meets Pablo Picasso, Georges Braque, and Henri Matisse.

**1908**

Exhibits with the Neue Sezession in Berlin and again in 1909. Miz designs scarves with Sonia Delaunay (then Sonia Uhde).

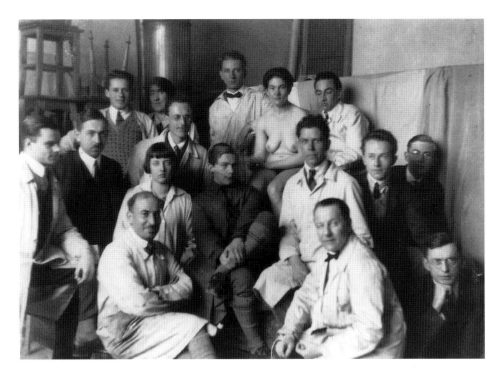

**The Hofmann School in Munich, 1926**

**1910**

First one-person exhibition held at Paul Cassirer Gallery, Berlin. Meets Robert Delaunay, with whom he designs patterns for Sonia Delaunay's Cubist fashions. During their close friendship, both men develop as colorists.

**1914**

Hans and Miz leave Paris for Corsica so that Hans can regain his health during a bout of what turned out to be tuberculosis. Called to Germany by the illness of his sister Rosa, they are caught on the Tegernsee by the outbreak of World War I.

**1915**

Disqualified for the army due to the aftereffects of his lung condition, and with the assistance of Freudenberg terminated by the war, Hofmann decides to teach to earn a living. In the spring, he opens the Hans Hofmann School of Fine Arts at 40 Georgenstraße, Munich.

**1918–29**

After the war, his school becomes known abroad and attracts foreign students such as Worth Ryder, Glenn Wessels, Louise Nevelson, Vaclav Vytlacil, Carl Holty, Alfred Jensen, and Ludwig Sander. Holds summer sessions at Tegernsee, Bavaria (1922),

**Maria (Miz) Hofmann**

Ragusa (1924), Capri (1925–27), St. Tropez (1928–29). Makes frequent trips to Paris. Has little time to paint but draws continually.

**1924**

Marries Miz Wolfegg on 5 June.

**1929**

A series of his drawings is reproduced by a photographic process known as *Lichtdrucke*.

**1930**

At the invitation of Worth Ryder, teaches in a summer session at the University of California, Berkeley, where Ryder is chairman of the Department of Art. Returns to Munich for the winter.

**1931**

In the spring, teaches at the Chouinard School of Art, Los Angeles, and again at Berkeley in the summer. Wessels helps him with the first translation of his book *Form und Farbe in der Gestaltung*, begun in 1904. Exhibits a series of drawings at the California Palace of the Legion of Honor, San Francisco, his first show in the United States.

**1932**

Returns to the Chouinard School of Art in the summer. Advised by Miz not to return to Munich because of a growing political hostility to intellectuals, settles in New York. Vaclav Vytlacil helps arrange a teaching position for him at the Art Students League.

**1932–33**

Summer sessions of the Hans Hofmann School of Fine Arts continue in St. Tropez (1932) and Murnau (1933), taught by Edmund Daniel Kinzinger. The school closes in the fall of 1933, and Miz gives up the lease in 1936.

**1933**

Spends the summer as guest instructor at the Thurn School of Art in Gloucester, Mass. In the fall, opens the Hans Hofmann School of Fine Arts at 444 Madison Avenue in New York. After a prolonged period of drawing, begins to paint again.

**1934**

Upon the expiration of his visa, travels to Bermuda to return with a permanent visa. Opens a summer school in Provincetown, Mass. The Hans Hofmann School of Fine Arts opens at 137 East 57th Street in New York.

**1936**

The Hofmann School moves to 52 West 9th Street.

**1938**

The Hofmann School moves to 52 West 8th Street. A planned European summer session (traveling to Paris, the Côte d'Azur, Italy, and Capri) is called off after Hitler moves into Austria in the spring. Delivers a lecture series once a month at the school in the winter of 1938–39, which is attended by the vanguard of the New York art world, including Arshile Gorky and Clement Greenberg.

**1939**

Miz Hofmann arrives in America. After a stay in New Orleans, joins her husband in Provincetown. They spend five months each summer in Provincetown and the rest of the year in New York.

**1941**

Becomes an American citizen. Delivers an address at the annual meeting of the American Abstract Artists at the Riverside Museum. One-person exhibition at the Isaac Delgado Museum of Art, New Orleans.

**Picasso and Hofmann, 1949**

**1942**

Hofmann's former student Lee Krasner introduces him to Jackson Pollock.

**1944**

First exhibition in New York at Art of This Century Gallery, arranged by Peggy Guggenheim. "Hans Hofmann, Paintings, 1941–1944" opens at the Arts Club in Chicago and travels on to the Milwaukee Art Institute in January 1945. Howard Putzel includes him in "Forty American Moderns" at 67 Gallery, New York. Also included in "Abstract and Surrealist Art in America" at the Mortimer Brandt Gallery, New York (arranged by Sidney Janis in conjunction with publication of Janis's book of the same title).

**1947**

Exhibitions at Betty Parsons Gallery in New York, in Pittsburgh, and at the Dallas Museum of Fine Arts. The Texas show travels to Denton, Tex.; Norman, Okla.; and Memphis. Begins to exhibit with the Kootz Gallery in New York. Kootz holds a one-person show of Hofmann's work each year until his death (with the exception of 1948 and 1956).

**1948**

Retrospective exhibition at the Addison Gallery of American Art in Andover, Mass., in conjunction with publication of his book, *Search for the Real and Other Essays*.

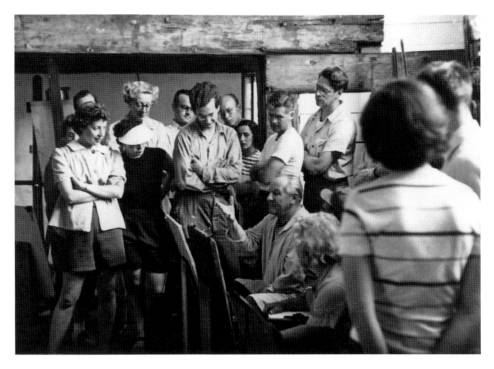

**School in Provincetown, ca. 1950**

**1949**

Travels to Paris to attend the opening of his exhibition at the Galerie Maeght and visits the studios of Picasso, Braque, Constantin Brancusi, and Joan Miró. Helps Fritz Bultman and Weldon Kees organize Forum 49, a summer series of lectures, panels, and exhibitions at Gallery 200 in Provincetown.

**1950**

Participates in a three-day symposium at Studio 35 in New York with William Baziotes, James Brooks, Willem de Kooning, Herbert Ferber, Theodoros Stamos, David Smith, and Bradley Walker Tomlin. Joins the Irascibles—a group of Abstract Expressionists—in an open letter protesting the exclusion of the avant-garde from an upcoming exhibition of American art at the Metropolitan Museum of Art in New York.

**1951**

Juries the 60th Annual Exhibition at the Art Institute of Chicago with Aline Louchheim and Peter Blume.

**1954**

One-person exhibition held at the Baltimore Museum of Art.

**1955**

Clement Greenberg organizes a small retrospective exhibition at Bennington College in Vermont.

**1956**

Designs mosaic murals for the lobby of the new William Kaufmann Building, architect William Lescaze, at 711 Third Avenue, New York. Retrospective held at the Art Alliance in Philadelphia.

**1957**

Retrospective exhibition held at the Whitney Museum of American Art, New York, which travels to Des Moines, San Francisco, Los Angeles, Seattle, Minneapolis, Utica, and Baltimore.

**1958**

Hofmann ceases teaching to devote devote himself full time to painting. He moves his studio into the New York and Provincetown schools. Completes a mosaic mural for the exterior of the New York School of Printing (Kelly and Gruzen, architects) at 439 West 49th Street.

**1960**

Represents the United States with Philip Guston, Franz Kline, and Theodore Roszak at the XXX Venice Biennale.

**1962**

Retrospective exhibition opens in Germany at the Fränkische Galerie am Marien-tor, Nuremberg, and travels to the Kölnischer Kunstverein, Cologne, and the Kongreßhalle, Berlin. In Munich, Neue Galerie im Künstlerhaus presents "Oils on Paper, 1961–1962." Awarded an honorary membership in the Akademie der Bildenden Künste in Nuremberg and an honorary Doctor of Fine Arts degree by Dartmouth College in Hanover, N.H.

**1963**

Miz Hofmann dies. Retrospective exhibition at the Museum of Modern Art organized by William Seitz travels throughout the United States and internationally to locations in South America and Europe, including Stuttgart, Hamburg, and Bielefeld. Signs a historic agreement to donate 45 paintings to the University of California at Berkeley and to fund the construction of a gallery in his honor at the new university museum, then in the planning stage. The exhibition "Hans

**Renate Hofmann**

Hofmann and His Students," organized by the Museum of Modern Art, circulates in the United States and Canada.

**1964**

Awarded an honorary Doctor of Fine Arts degree from the University of California at Berkeley. Serves on the jury for the 1964 Solomon Guggenheim International Award. Becomes a member of the National Institute of Arts and Letters, New York. Renate Schmitz inspires the *Renate* series.

**1965**

Awarded an honorary Doctor of Fine Arts degree by Pratt Institute, New York. Marries Renate Schmitz on 14 October.

**1966**

Hans Hofmann dies on 17 February in New York.

# Exhibitions

Note: * denotes solo exhibition.

**1908**
Berlin: Neue Sezession.

**1909**
Berlin: Neue Sezession.

**1910**
Berlin: Paul Cassirer Galerie, "Hofmann-Kokoschka."

**1931**
* Berkeley, California: University of California, July.
* San Francisco: California Palace of the Legion of Honor, August.

**1941**
* New Orleans: Isaac Delgado Museum of Art, "Hans Hofmann," March.

**1943**
New York: The American Fine Arts Society, "Exhibition of Distinguished Artists." On the occasion of the 50th year on 57th Street, artists associated with the Art Students League over 68 years, 7–28 February.

**1944**
* Chicago: The Arts Club of Chicago, "Hans Hofmann, Paintings 1941–1944," 3–25 November.
Cincinnati, Ohio: Cincinnati Art Museum, "Abstract and Surrealist Art in the United States," 8 February–12 March. Organized by the San Francisco Museum of Art and selected by Sidney Janis. Traveled to Denver Art Museum (26 March–23 April), Seattle Art Museum (7 May–10 June), Santa Barbara Museum of Art (June–July), San Francisco Museum of Art (July).
* New York: Art of This Century Gallery, "First Exhibition: Hans Hofmann," 7–31 March.
New York: Mortimer Brandt Gallery, "Abstract and Surrealist Art in America," 29 November–

30 December. Arranged by Sidney Janis in conjunction with publication of his book *Abstract and Surrealist Art in America* (New York: Reynal and Hitchcock).
New York: 67 Gallery, "Forty American Moderns," December.
Urbana, Ill.: University of Illinois, December.

**1945**
* Milwaukee: Milwaukee Art Institute, "Hans Hofmann," 1–14 January.
* New York: 67 Gallery, "Hans Hofmann: Recent Works," 14 April–10 May.
New York: 67 Gallery, "A Problem for Critics," 14 May–7 July.
New York: Whitney Museum of American Art, "1945 Annual Exhibition of Contemporary American Painting," 27 November–10 January 1946.
San Francisco: California Palace of the Legion of Honor, "Contemporary American Paintings," 17 May–17 June.

**1946**
* Hollywood, Calif.: American Contemporary Gallery, "Hans Hofmann," 14 May–10 June. Arranged in association with the Betty Parsons Gallery.
* New York: Mortimer Brandt Gallery, 18–30 March. Arranged by Betty Parsons.
Provincetown, Mass.: Provincetown Art Association, August.

**1947**
Andover, Mass.: Addison Gallery of American Art, "Seeing the Unseeable," 22 January–3 March.
Chicago: The Art Institute of Chicago, "Abstract and Surrealist American Art," 6 November–11 January 1948. 58th Annual Exhibition of American Paintings and Sculpture.
* Dallas: Dallas Museum of Fine Arts, "Hans Hofmann: Space Paintings," February. Traveled

to the Art Department of the Texas State College for Women (Denton, 6 March–3 April), University of Oklahoma (Norman, 15–30 April), Memphis Academy of Arts (May–June).
New York: Betty Parsons Gallery, "The Ideographic Picture," 20 January–8 February.
* New York: Betty Parsons Gallery, "Hans Hofmann" 24 March–12 April.
* New York: Kootz Gallery, "Hans Hofmann," 23 November–13 December.
New York: Whitney Museum of American Art, "1947 Annual Exhibition of Contemporary Painting," 6 December–25 January 1948.
* Pittsburgh: Pittsburgh Arts and Crafts Center and Abstract Group of Pittsburgh, "Hans Hofmann," 20 December–11 January 1948.
Provincetown, Mass.: Shore Studios, Group exhibit, August.

## 1948

* Andover, Mass.: Addison Gallery of American Art, "Hans Hofmann: Painter and Teacher." Retrospective in conjunction with publication of Hofmann's *Search for the Real and Other Essays,* 2 January–9 February.
Iowa City: University of Iowa, "Fourth Summer Exhibition of Contemporary Art," June–July.
New York: Kootz Gallery, "Women: A Collaboration of Artists and Writers," accompanied by "An Appreciation," by Tennessee Williams.
New York: Whitney Museum of American Art, "1948 Annual Exhibition of Contemporary American Painting," 13 November–2 January 1949.
Urbana: University of Illinois, "Contemporary American Painting and Sculpture," 29 February–28 March.

## 1949

* New York: Kootz Gallery, "Hans Hofmann," 14 September–3 October.
New York: Kootz Gallery, "The Intrasubjectives," 14 September–3 October.
* New York: Kootz Gallery, "Recent Paintings by Hans Hofmann," 15 November–5 December.
New York: Whitney Museum of American Art, "1949 Annual Exhibition of Contemporary American Painting," 16 December–5 February 1950.
* Paris: Galerie Maeght, "Hans Hofmann, Peintures." Arranged by Kootz Gallery. January.
Provincetown, Mass.: Gallery 200, "Forum '49," Summer.

## 1950

New York: Kootz Gallery, "Black or White," March.
New York: Kootz Gallery, "The Muralist and the Modern Architect," 3–23 October.
* New York: Kootz Gallery, "Hans Hofmann: New Paintings," 24 October–13 November.
New York: Whitney Museum of American Art, "1950 Annual Exhibition of Contemporary American Painting," 10 November–31 December.
San Francisco: California Palace of the Legion of Honor, "4th Annual Exhibition of Contemporary American Painting," 25 November–1 January 1951.
Urbana: University of Illinois, "Contemporary American Painting and Sculpture," 6 February–2 April. Purchase Award, Krannert Art Museum, University of Illinois.

## 1951

Beverly Hills, Calif.: Frank Perls Gallery, "17 Modern American Painters," January.
Chicago: The Art Institute of Chicago, "60th Annual American Exhibition of Paintings and Sculpture," 25 October–16 December.
Minneapolis: University of Minnesota, "40 American Painters, 1940–1950," 4 June–30 August. Statement by Hans Hofmann.
Minneapolis: Walker Art Center, "5th Biennial Exhibition of American Painting," June.
New York: 60 E. 9th Street, "9th Street Exhibition of Paintings and Sculpture," 21 May–10 June.
New York: Sidney Janis Gallery, "American Vanguard Art for Paris Exhibition," 26 December–5 January 1952. Traveled to the Galerie de France, Paris, 26 February–15 March 1952.
New York: Kootz Gallery, "Intimate Media," May.
New York: Kootz Gallery, "Resumé of the 1950–51 Season: Paintings and Sculpture by the Gallery's Artists," 4–29 June.
New York: Kootz Gallery, "Summer Souvenirs," 10–29 September.
* New York: Kootz Gallery, "New Paintings by Hans Hofmann," 13 November–1 December. Statement by Hofmann, "Space Pictorially Realized through the Intrinsic Faculty of the Colors to Express Volume" (Provincetown, 26 September 1951).
New York: The Museum of Modern Art, "Abstract Painting and Sculpture in America," 23 January–25 March.

New York: Whitney Museum of American Art, "1951 Annual Exhibition of Contemporary American Painting," 8 November–6 January 1952.
Philadelphia: Pennsylvania Academy of the Fine Arts, "146th Annual Exhibition of Painting and Sculpture," 21 January–25 February. Also included in 1953, 1954 (J. Henry Scheidt Prize), 1956, 1958, 1960, 1962, 1966.
Urbana: University of Illinois, "Exhibition of Contemporary American Painting," 4 March–15 April.

## 1952

Buffalo, N.Y.: Albright Art Gallery, "Expressionism in American Painting," 10 May–29 June.
Chicago: The Art Institute of Chicago, "12th Annual Exhibition of the Society for Contemporary Art, Chicago," 7 May–8 June. Purchase prize.
Minneapolis: University of Minnesota, "Space in Painting," 28 January–7 March.
Minneapolis: Walker Art Center, "Contemporary American Painting and Sculpture, Collection of Mr. and Mrs. Roy Neuberger," 24 May–10 August.
* New York: Kootz Gallery, "Hans Hofmann: Recent Paintings," 28 October–22 November.
New York: Whitney Museum of American Art, "1952 Annual Exhibition of Contemporary American Painting," 6 November–4 January 1953.
New York: Wildenstein Gallery, "70 Twentieth-Century American Paintings" 21 February–22 March.
Pittsburgh: Carnegie Institute, "The 1952 Pittsburgh International Exhibition of Contemporary Painting," 16 October–14 December. Also included in 1958 and 1964 exhibitions.
St. Louis: The Artists' Guild, 16 March–10 April. Fred Olsen Collection.
Urbana: University of Illinois, "Contemporary American Painting," 2 March–13 April.

## 1953

Bloomfield Hills, Mich.: Museum of Cranbrook Academy of Art, "First Biennial Exhibition: American Painting—Sculpture," 2 October–1 November.
Minneapolis: Walker Art Center, "Four Abstract Expressionists," February.
Minneapolis: Walker Art Center, "The Classic Tradition in Contemporary Art," 24 April–28 June.

* New York: Kootz Gallery, "Hans Hofmann: The First Showing of Landscapes Created from 1936–39," 27 April–20 May.
* New York: Kootz Gallery, "Hans Hofmann: New Paintings Created in 1953," 16 November–12 December.
New York: Whitney Museum of American Art, "1953 Annual Exhibition of Contemporary American Painting," 15 October–6 December.
Pomona, Calif.: The Los Angeles County Fair, "Painting in the U.S.A.: 1721 to 1953," 18 September–4 October.
* Provincetown, Mass.: Kootz Gallery, "Hans Hofmann," Summer.
San Francisco: San Francisco Museum of Art, Fauve exhibition, March.
Urbana: University of Illinois, "Contemporary American Painting and Sculpture," 1 March–12 April.

## 1954

* Baltimore: Baltimore Museum of Art, "Paintings by Hans Hofmann," 5 October–21 November.
* Boston: Boris Mirski Gallery, "Hans Hofmann," January.
* New York: Kootz Gallery, "Hofmann: New Paintings," 15 November–11 December. Statements by Hofmann: "The Resurrection of the Plastic Arts" and "The Mystery of Creative Relations" (reprinted in exhibition catalogue through courtesy of *New Ventures* magazine).
New York: The Museum of Modern Art, "Paintings from the Museum Collection," 16 November–December.
New York: Sidney Janis Gallery, "Nine American Painters Today," 4–23 January. De Kooning, Still, Tobey, Pollock, Rothko, Davis, Kline, Gorky, and Hofmann.
* Provincetown, Mass.: Kootz Gallery, "Hans Hofmann," summer.
* Washington, D.C.: Watkins Gallery, The American University, December.

## 1955

* Bennington, Vt.: Bennington College, "A Retrospective Exhibition of the Paintings of Hans Hofmann," May. Selected by Clement Greenberg.
Fort Dodge, Iowa: Des Moines Art Center, "Communicating Art from Midwest Collections," 13 October–6 November.

* New York: Kootz Gallery, "Hans Hofmann: New Paintings," 7 November–3 December.
New York: Whitney Museum of American Art, "Annual Exhibition: Paintings, Sculpture, Watercolors, Drawings," 12 January–20 February.
New York: Whitney Museum of American Art, "1955 Annual Exhibition of Contemporary American Painting," 9 November–8 January 1956.
Urbana: University of Illinois, "Contemporary American Painting and Sculpture," 27 February–3 April.

## 1956

Minneapolis: Walker Art Center, "Expressionism, 1900–1955," traveled to Institute of Contemporary Art (Boston), San Francisco Museum of Art, Cincinnati Art Museum and Contemporary Arts Center, Baltimore Museum of Art, Albright Art Gallery (Buffalo, N.Y.).
* New Brunswick, N.J.: Rutgers University, April–May.
New York: The Museum of Modern Art, "The Embellished Surface," Circulating exhibition.
* Philadelphia: The Art Alliance, "Hans Hofmann," 14 March–1 April. Retrospective exhibition.

## 1957

Minneapolis: Minneapolis Institute of Arts, "American Paintings: 1945–1957."
* New York: Kootz Gallery, "Hans Hofmann: New Paintings," 7–26 January.
New York: Poindexter Gallery, "The 30s: Painting in New York," 3–20 June.
* New York: Whitney Museum of American Art, "A Retrospective Exhibition of Hans Hofmann," 24 April–16 June. Organized in association with the Art Galleries of the University of California, Los Angeles, traveled to Des Moines Art Center (5 July–4 August), San Francisco Museum of Art, Art Galleries of the University of California (Los Angeles), Seattle Art Museum, Walker Art Center (Minneapolis), Munson-Williams-Proctor Institute (Utica, N.Y.), Baltimore Museum of Art.
New York: Whitney Museum of American Art, "1957 Annual Exhibition: Sculpture—Paintings—Watercolors," 20 November–12 January 1958.
Urbana: University of Illinois, "Contemporary American Painting and Sculpture," 3 March–7 April.

## 1958

Buffalo, N.Y.: Albright Art Gallery, The Buffalo Fine Arts Academy, "Contemporary Art—Acquisitions, 1957–1958," 8 December–18 January 1959.
Dallas: Dallas Museum for Contemporary Arts, "Action Painting," 5 March–13 April.
East Hampton, N.Y.: Signa Gallery, international exhibition, 22 August–September.
* New York: Kootz Gallery, "New Paintings by Hans Hofmann," 7–25 January.
New York: Whitney Museum of American Art, "Nature in Abstraction: The Relation of Abstract Painting and Sculpture to Nature in Twentieth-Century American Art," 14 January–16 March. Traveled to The Phillips Gallery (Washington, D.C., 2 April–4 May), Fort Worth Art Center (2–29 June), Los Angeles County Museum of Art (16 July–24 August), San Francisco Museum of Art (10 September–12 October), Walker Art Center (Minneapolis, 29 October–14 December), City Art Museum of St. Louis (7 January–8 February).
New York: Whitney Museum of American Art, "Annual Exhibition: Sculpture—Paintings—Watercolors—Drawings," 19 November–4 January 1959.
Salt Lake City: University of Utah, "Fourth Annual Invitational Exhibition," March.

## 1959

American Federation of Arts traveling exhibition: "Ten Modern Masters of American Art: 30 Works Selected from the Joseph H. Hirshhorn Collection," circulated 1959–60.
Chicago: The Art Institute of Chicago, "63rd Annual American Exhibition," 2 December–31 January 1960. Flora Mayer Witkowsky Prize of $1,500.
Ithaca, N.Y.: Andrew Dickson White Museum of Art, Cornell University, April.
Kassel, Germany: Museum Fridericianum, "Documenta II '59: Art after 1945," 11 July–11 October.
* New York: Kootz Gallery, "Hans Hofmann: Paintings of 1958," 6–17 January.
* New York: Kootz Gallery, "Hans Hofmann: Early Paintings," 20–31 January. Selected by Clement Greenberg.
Philadelphia: Pennsylvania Academy of the Fine Arts, "Paintings, Drawings, Prints, and Sculpture Owned by Fourteen Philadelphia Artists," 7 November–6 December.

Providence: Museum of Art, Rhode Island School of Design, "Paintings since 1945: A Collection in the Making, Lent by Richard Brown Baker," 18 March–19 April.

## 1960
Berkeley, Calif.: Alfred L. Kroeber Hall and the Galleries of the Art Department, University of California, "Art from Ingres to Pollock: Painting and Sculpture since Neoclassicism," 6 March–3 April.
Cleveland: The Cleveland Museum of Art, "Paths of Abstract Art," October.
Columbus, Ohio: Columbus Gallery of Fine Arts, "Contemporary American Painting," 14 January–18 February.
Mexico City: Museo Nacional de Arte Moderna, Palacio de las Bellas Artes, "Il Bienal Interamericana," 5 September–5 November.
Minneapolis: Walker Art Center, "60 American Painters, 1960," 3 April–8 May.
Munich: Städtische Galerie, "Neue Malerei: Form, Struktur, Bedeutung," 10 June–28 August.
* New York: Kootz Gallery, "Hans Hofmann, Paintings of 1959," 5–23 January.
Venice: XXX Venice Biennale, "Stati Uniti d'America—Quattro Artisti Americani: Guston, Hofmann, Kline, Roszak," June–October.

## 1961
American Federation of Arts traveling exhibition: "Abstract Expressionist Drawings," February–October. Partial listing: Southwestern University (Georgetown, Tex.), Ohio State University, Utah Museum of Fine Arts.
Chicago: The Art Institute of Chicago, "64th American Exhibition: Paintings—Sculpture," 6 January–5 February. Ada S. Garrett Prize, $1500.
Minneapolis: Walker Art Center, "80 Works from the Richard Brown Baker Collection," 12 March–16 April.
* New York: Kootz Gallery, "Hans Hofmann," 7–25 March.
New York: Solomon R. Guggenheim Museum, "American Abstract Expressionists and Imagists," 13 October–31 December.
New York: Whitney Museum of American Art, "Annual Exhibition 1961: Contemporary American Painting," 13 December–4 February 1962.
* San Francisco: Feingarten Galleries, "Hans Hofmann," 30 June–24 July.

Urbana: Krannert Art Museum, University of Illinois, "Contemporary American Painting and Sculpture," 26 February–2 April.
Washington, D.C.: The Corcoran Gallery of Art, "Twenty-seventh Biennial Exhibition of Contemporary American Painting," 14 January–26 February.

## 1962
Caracas: Museo de Bellas Artes, "Dibujos acuarelas abstractos USA," January. Under the auspices of the International Council of the Museum of Modern Art. Traveled to Museu de Arte Moderna do Rio de Janeiro (March).
* Hanover, N.H.: Hopkins Center, Dartmouth College, "Paintings by Hans Hofmann," 8–30 November.
London: USIS Gallery, American Embassy, "Vanguard American Painting," 28 February–30 March. Traveled to Yugoslavia (1961–62).
* Munich: Neue Galerie im Künstlerhaus, "Oils on Paper, 1961–1962," March.
* New York: Kootz Gallery, "Hans Hofmann: New Paintings," 2–20 January.
New York: Kootz Gallery, "Final Exhibition of the 1961–1962 Season," 8 May–26 May.
New York: Kootz Gallery, October.
New York: Whitney Museum of American Art, "Geometric Abstraction in America," 20 March–13 May.
* Nuremberg: Fränkische Galerie am Marientor, "Hans Hofmann," March. Large retrospective exhibition, subsequently shown at Kölnischer Kunstverein (Cologne), Kongreßhalle (Berlin), and Städtische Galerie (Munich).
Paris: Galerie Anderson-Mayer, group show with Norman Bluhm, Michael Goldberg, William Scott, Frank Roth, Lucio Fontana, December.
Richmond: Virginia Museum of Fine Arts, "American Paintings 1962," 9 March–15 April.
Seattle: Seattle World's Fair, "Art since 1950, American," 21 April–21 October. Traveled to Rose Art Museum (Brandeis University, Waltham, Mass.).

## 1963
American Federation of Arts traveling exhibition: "Provincetown: A Painter's Place," January–October.
Chicago: The Art Institute of Chicago, "66th Annual American Exhibition: Directions in Contemporary Painting and Sculpture," 11 January–10 February. Frank G. Logan Prize.

Denver: International House, "Hans Hofmann and His Students," 6–27 May. Organized by the Museum of Modern Art and circulated from 1963 to 1965 to Michigan State University (East Lansing, 1–22 July), Akron Art Institute (3–28 September), Indiana University Museum of Art (Bloomington, 11 October–2 November), Auburn University (Auburn, Ala.,18 November–9 December), Hunter Gallery of Art (Chattanooga, Tenn., 2–23 January 1964), Richmond Artist's Association (Richmond, Va., 9 February–1 March), University of North Carolina (Greensboro, 17 March–7 April), Ohio University (Athens, 21 April–12 May), University of South Florida (Tampa, 1–22 June), Portland Art Museum (Portland, Me., 18 September–13 October), State University College (Oswego, N.Y., 26 October–16 November), Ackland Memorial Art Center, University of North Carolina (Chapel Hill, 5–26 January 1965), Goucher College (Towsonn, Md., 8 February–1 March), Joe and Emily Lowe Art Gallery at the University of Miami (Coral Gables, Fla., 17 March–7 April).
Des Moines: Des Moines Art Center, "Art of the Twentieth Century Collected by James S. and Dorothy Schramm," 27 October–19 November.
Minneapolis: Minneapolis Institute of Arts, "Four Centuries of American Art," November–December.
New York: Jewish Museum, "Black and White," 12 December–3 February 1964.
* New York: Kootz Gallery, "Hans Hofmann," 5–23 March.
New York: M. Knoedler and Company, "Paintings from the Joseph H. Hirshhorn Foundation Collection: A View of the Protean Century," 31 October–24 November. Traveling exhibition selected by H. H. Arnason.
* New York: The Museum of Modern Art, "Hans Hofmann," 11 September–28 November. Catalogue text by William Seitz with excerpts from the artist's writings (64 pages, biography and bibliography). Retrospective exhibition, traveled to Rose Art Museum, Brandeis University (Waltham, Mass., 6 January–2 February, 1964), Isaac Delgado Museum of Art (New Orleans, 21 February–15 March), Albright-Knox Art Gallery (Buffalo, N.Y., 30 March–26 April), University of California, Berkeley (11 May–7 June), Gallery of Modern Art (Washington, D.C., 21 June–21 July), Museo de Arte Moderno de Buenos Aires (10–26 September), Museo de Bellas

Artes (Caracas, 29 November–13 December), Stedelijk Museum (Amsterdam, 29 January– 15 March 1965), Galleria Civica d'Arte Moderna (Turin, 31 March–30 April), Württembergischer Kunstverein (Stuttgart, 13 May–13 June), Kunstverein in Hamburg (Amerika Haus) (2–31 July), Städtisches Kunsthaus (Bielefeld, 12 September–10 October).

New York: Solomon R. Guggenheim Museum, "Twentieth-Century Master Drawings," 6 November–5 January 1964. In collaboration with University Gallery, University of Minnesota (Minneapolis, 3 February–15 March), and Fogg Art Museum, Harvard University (Cambridge, Mass., 6 April–24 May).

New York: Thibaut Gallery, "According to the Letter," 15 January–9 February.

New York: Whitney Museum of American Art, "Annual Exhibition 1963: Contemporary American Painting," 11 December–2 February 1964.

Oswego: State College of New York College of Education at Oswego, "Centennial Exhibition," October.

Paris: Centre Culturel Américain, "de A à Z 1963," 10 May–20 June. Thirty-one painters chosen by the Art Institute of Chicago. Exhibition organized by the U.S. ambassador in Paris.

* Paris: Galerie Anderson-Mayer, "Oils on Paper," 23 April–18 May.

* Santa Barbara, California: Santa Barbara Museum of Art, "Paintings by Hans Hofmann," 1–24 February.

Urbana: University of Illinois, "11th Exhibition of Contemporary American Painting and Sculpture, 1963," 3 March–7 April.

Waltham, Mass.: Poses Institute of Fine Arts, Brandeis University, "New Directions in American Painting." Traveled to Munson-Williams-Proctor Institute (Utica, N.Y., 1 December–5 January 1964), Isaac Delgado Museum of Art (New Orleans, 21 February–15 March), Atlanta Art Association (18 March–22 April), J. B. Speed Art Museum (Louisville, 4 May–7 June), Art Museum, Indiana University (Bloomington, 22 June–20 September), Washington University (St. Louis, 5 October–30 October), The Detroit Institute of Arts (10 November–6 December).

Washington, D.C.: The Corcoran Gallery of Art, "The New Tradition: Modern Americans before 1940," 27 April–2 June.

## 1964

* Berkeley: Worth Ryder Art Gallery, University of California, "Recent Gifts and Loan of Paintings by Hans Hofmann," 2 April–3 May.

Bonn: United States ambassador's residence, "Art in Embassies," July 1964–December 1965.

* Copenhagen, Denmark: American Art Gallery, "Hans Hofmann: Oils," 18 April–9 May.

* New York: Kootz Gallery, "Hans Hofmann: Paintings, 1963," 18 February–7 March.

New York: Solomon R. Guggenheim Museum, "Guggenheim International Award 1964," January–March. Serves on jury, work included *hors concours*.

St. Louis: City Art Museum, "200 Years of American Paintings," 1 April–31 May.

## 1965

Ann Arbor: The University of Michigan Museum of Art, "One Hundred Contemporary American Drawings," 24 February–28 March.

Des Moines, Iowa: Des Moines Art Center, "Collection of American Republic Insurance Company," January.

Los Angeles: Los Angeles County Museum of Art, "New York School: The First Generation. Paintings of the 1940s and 1950s," 7 June–8 August.

* New York: Kootz Gallery, "Hans Hofmann, 85th Anniversary: Paintings of 1964," 16 February–6 March.

New York: The Mead Corporation, "Art across America." Traveled to the Toledo Museum of Art, Cleveland Institute of Art, Memorial Art Gallery (University of Rochester) in 1965; in 1966 to Wadsworth Atheneum (Hartford, Conn.), The Contemporary Arts Center (Cincinnati), Flint Institute of Arts (Flint, Mich.), Brooks Memorial Art Gallery (Memphis), Pepsi-Cola Exhibition Gallery (New York), J. B. Speed Art Museum (Louisville), Joslyn Art Museum (Omaha), Philbrook Art Center (Tulsa); and in 1967 to the Isaac Delgado Museum of Art (New Orleans), Commercial Museum (Philadelphia), Henry Gallery (University of Washington, Seattle), Portland State College, La Jolla Museum of Art.

New York: The Metropolitan Museum of Art, "Three Centuries of American Painting," 9 April–17 October.

New York: Whitney Museum of American Art, "1965 Annual Exhibition of Contemporary American Painting," 8 December–30 January 1966.

New York: Whitney Museum of American Art, "Art: USA: Now," March. Traveling exhibition sponsored in 1962 by Johnson Wax Co., in Germany, Denmark, and Japan before circulating in America.

Ridgefield, Conn.: Larry Aldrich Museum, "Art of the 50s and 60s," 25 April–5 July. Selections from the Richard Brown Baker Collection.

Syracuse: New York State Exposition, "Five Distinguished American Artists: Dickinson, Hofmann, Hopper, Shahn, Snyder," 31 August–6 September.

Urbana: Krannert Art Museum, University of Illinois, "Contemporary American Painting and Sculpture," 7 March–11 April.

## 1966

Cleveland, Ohio: The Cleveland Museum of Art, "Fifty Years of American Art," 15 June–21 July.

* New York: Kootz Gallery, "Hans Hofmann at Kootz," 1–26 February.

New York: The Museum of Modern Art, "Recent Acquisitions: Painting and Sculpture," 6 April–5 June.

* Stanford, Calif.: Stanford Art Museum, "Hans Hofmann: 21 Paintings from the Collection of the University of California, Berkeley," 22 June–17 August.

Tokyo: National Museum of Modern Art, "Two Decades of American Painting," 15 October–27 November. Selected by the Museum of Modern Art, traveled to the National Museum of Modern Art (Kyoto); Lalit Kala Akademi (New Delhi, June 1967); and Melbourne, Australia.

Washington, D.C.: National Collection of Fine Arts, Smithsonian Institution, "The American Landscape: A Changing Frontier," 28 April–19 June.

Winnipeg, Manitoba: Winnipeg Art Gallery, "Contemporary Americans," February.

## 1967

American Federation of Arts traveling exhibition: "American Paintings: The 1940s," April 1967–June 1968. Exhibition selected by Lamar Dodd and William D. Paul, Jr.

American Federation of Arts traveling exhibition: "American Still Life Painting," October 1967–November 1968.

American Federation of Arts traveling exhibition: "American Masters: Art Students League," 1967–68.

Berkeley: University Art Gallery, University of California, "Selection 1967: Recent Acquisitions in Modern Art," 20 June–10 September.
Grand Rapids, Mich.: Grand Rapids Art Museum, "Twentieth-Century American Painting," 1–30 April.
* New York: André Emmerich Gallery, "Hans Hofmann," 21 January–9 February.
New York: Marlborough-Gerson Gallery, "The New York Painter: A Century of Teaching, Morse to Hofmann," 27 September–14 October.
Provincetown, Mass.: Tirca Karlis Gallery, "Hofmann and His Contemporaries," July.

**1968**
American Federation of Arts traveling exhibition: "A University Collects: The University of California, Berkeley," March 1968–February 1970.
American Federation of Arts traveling exhibition: "American Painting: The 1950s," 1968–69. Selected by Gordon B. Washburn.
* Chicago: Richard Gray Gallery, "Hans Hofmann, Paintings," 31 January–2 March.
Cincinnati: Cincinnati Art Museum, "American Paintings on the Market Today, V," 9 April–12 May.
* Honolulu, Hawaii: Honolulu Academy of the Arts, "21 Hofmanns from Berkeley," 29 March–5 May.
* La Jolla, Calif.: La Jolla Museum of Art, "Paintings by Hans Hofmann," 25 May–30 June.
Mexico City: Museo de Arte Moderno de Chapultepec, Olympic Games Art Festival, "Selected Works of World Art," 1 October–30 November.
Milwaukee, Wisc.: Milwaukee Art Center, "The Collection of Mrs. Harry Lynde Bradley," 25 October–23 February, 1969.
* New York: André Emmerich Gallery, "Hans Hofmann," 6–31 January.
* New York: Martha Jackson Gallery, "New Acquisitions and Hans Hofmann Works on Paper from the 40s and 50s," October.
New York: The Metropolitan Museum of Art, "New York Collects," 3 July–2 September.
New York: Whitney Museum of American Art, "The 1930s: Painting and Sculpture in America," 15 October–1 December.
Providence: Museum of Art, Rhode Island School of Design, "An American Collection: The Neuberger Collection of Paintings, Drawings and Sculpture," May–June.

**1969**
* Boston: Obelisk Gallery, "Hans Hofmann: Works of the Forties."
* New York: André Emmerich Gallery, "Hans Hofmann: Ten Major Works," 11–30 January.
New York: The Metropolitan Museum of Art, "New York Painting and Sculpture: 1940–1970," 16 October–8 February 1970.
* Philadelphia: Makler Gallery, "Hans Hofmann," 18 April–22 May.
* Toronto: David Mirvish Gallery, "Hans Hofmann," 22 March–15 April.
Washington, D.C.: Gallery on the Hill, Office of Representative Edward L. Koch, July 1969–July 1970.

**1970**
Berkeley: University Art Museum, University of California, "Excellence in the University Community," September. Inaugural exhibition.
* Berkeley: University Art Museum, University of California. Opening of the Hans Hofmann wing with a permanent collection of 45 works. 6 November.
Bloomington: Fine Arts Museum, Indiana University, "The American Scene, 1900–1970," 6 April–17 May.
Buffalo, N.Y.: Albright-Knox Art Gallery, "Color and Field 1890–1970." Traveling exhibition, 15 September–28 March 1971, to Dayton Art Institute (Dayton, Ohio) and the Cleveland Museum of Art.
* Detroit: J. L. Hudson Gallery, "Hans Hofmann: Oils and Watercolors," 1–25 April.
* Katonah, N.Y.: Katonah Gallery, "Hans Hofmann," 2 August–13 September.
* London: Waddington Galleries II, "Hans Hofmann, Paintings," 9 June–4 July.
Montclair, N.J.: Montclair Art Museum, "The Recent Years," 12 April–17 May.
* New York: André Emmerich Gallery, "Hans Hofmann: Paintings of the 40s, 50s, and 60s," 3–22 January.
New York: The Metropolitan Museum of Art, "Masterpieces of Fifty Centuries," 13 November–February 1971. One room devoted to Hofmann's work.
New York: Solomon R. Guggenheim Museum, "1900–1970: A Tenth-Anniversary Selection from the Guggenheim Museum Collection," 1 May–13 September.
Washington, D.C.: National Gallery of Art, "Great American Paintings from the Boston and Metropolitan Museums," 30 November–10 January 1971. Traveled to the City Art Museum (St. Louis) and the Seattle Art Museum.

**1971**
* New York: André Emmerich Gallery, "Hans Hofmann," 9 January–3 February.
New York: Solomon R. Guggenheim Museum, "Summer Show 1971," 11 June–12 September.
New York: The American Academy of Arts and Letters, "Memorial Exhibition: Lee Gatch, Hans Hofmann, Edward Hopper, Henry Schnakenberg, Charles Sheeler," 4 March–10 April.
New York: Whitney Museum of American Art, "The Structure of Color," 25 February–18 April.

**1972**
Amherst, Mass.: Amherst College, "Twenty from Brandeis," 27 November–20 December.
* Basel: Galerie Liatowitsch, June.
Birmingham, Ala.: Birmingham Museum of Art, "American Watercolors, 1850–1972," 15 January–13 February.
* Boston: Harcus-Krakow Gallery, "Hans Hofmann," Winter.
* Chicago: Richard Gray Gallery, "Hans Hofmann: Paintings," February.
* Chicago: Richard Gray Gallery, "Hans Hofmann: Small Paintings 1965," October.
* Cologne: Onnash Gallery, "Hans Hofmann," Spring.
* Dallas: Janie C. Lee Gallery, "Hans Hofmann," December.
* New York: André Emmerich Gallery, "Hans Hofmann," 8–27 January.
* New York: The Metropolitan Museum of Art, "The Renate Series," 16 October–31 December. Traveled to Albright-Knox Art Gallery (Buffalo, N.Y., 15 January–28 February 1973).
New York: Solomon R. Guggenheim Museum, "Pieces of the Post-War Era," 7 September–15 October.
* Seattle: Current Editions, "Hans Hofmann," July.
* Toronto: David Mirvish Gallery, "Hans Hofmann," Spring.

**1973**
* Atlanta: Aronson Gallery, "Hans Hofmann," May.
* Boston: Harcus Krakow Rosen Sonnabend, "Hans Hofmann, Paintings," 17 November–22 December.

Carlyle, Pa.: Dickinson College, "Appreciating Abstract Expressionism," 2–20 April.

★ London: Waddington Galleries III, "Hans Hofmann Watercolors," 10 July–4 August.

Los Angeles: Margo Leavin Gallery, "Drawings," 13 March–15 April.

★ Los Angeles: Nicholas Wilder Gallery, "Hans Hofmann Paintings on Paper," 30 March–14 April.

★ Nashville: Tennessee Fine Arts Center at Cheekwood, "Hans Hofmann," 9 June–15 July.

★ New York: André Emmerich Gallery, "Hans Hofmann: 10 Major Works," 6–24 January.

★ New York: André Emmerich Gallery, "Hans Hofmann Works on Paper," 15 September–11 October.

★ New York: Rosa Esman Gallery, "Hans Hofmann: Provincetown Drawings," May.

Philadelphia: Makler Gallery, "American Abstract Expressionists," 7 May–16 June.

Providence: Museum of Art, Rhode Island School of Design, "The Albert Pilavin Collection of 20th-Century American Art II," 23 October–25 November.

★ San Francisco: John Berggruen Gallery, "Hans Hofmann Paintings on Paper, 1941–1948," 12 June–14 July.

★ St. Louis: Greenberg Gallery, "Hans Hofmann," February.

Toronto: David Mirvish Gallery, "Ten Years Ago . . . an Exhibition of Paintings from 1965," Fall.

★ Toronto: David Mirvish Gallery, "Works on Paper by Hans Hofmann," 3 December–3 January 1974.

★ Washington, D.C.: The Corcoran Gallery of Art, "Hans Hofmann: 52 Works on Paper," 2 June–15 July. International Exhibitions Foundation tour through December 1975: Museum of Art, University of Michigan (Ann Arbor, 15 October–15 November), University Art Museum (University of California, Berkeley), Arkansas Art Center (Little Rock), Tyler Museum of Art (Tyler, Texas), Palm Springs Desert Museum (Palm Springs, Calif.), Wichita State University (Wichita, Kans.).

## 1974

International Exhibitions Foundation: "American Self-Portraits," Traveling exhibition.

★ International Exhibitions Foundation: "Hans Hofmann: A Colorist in Black and White." Traveling exhibition of 53 drawings curated by the International Exhibitions Foundation in cooperation with the André Emmerich Gallery (New York). Currier Gallery of Art (Manchester, N.H., 15 October–15 November), Georgia Museum of Art (University of Georgia, Athens, 15 January–15 February 1975), Fort Lauderdale Museum of the Arts (Fort Lauderdale, Fla., 1–31 March), Bowers Museum (Santa Ana, Calif., 15 April–15 May), Colorado Springs Fine Arts Center (1–30 June), Washington University Gallery of Art (St. Louis, 15 July–15 August), Musée d'Art Contemporain (Montreal, 1–30 September), Ivan Wilson Center for Fine Arts Gallery (Bowling Green, Ky., 15 October–15 November), Hunter Museum of Art (Chattanooga, Tenn., 1–31 December), Joslyn Art Museum (Omaha, Nebr., 15 January–15 February 1976), Palm Springs Desert Museum (Palm Springs, Calif., 1–31 March), Bowers Museum (Santa Ana, Calif., 1 June–15 August), Fine Arts Gallery, California State University (Northridge, 1–30 September), University of Iowa Museum of Art (Iowa City, 1–31 March 1977), U.S.I.A. Latin American tour (Bogotá, Quito, Buenos Aires, Mexico City, Panama City, 1 November 1977–30 September 1978), Trisolini Gallery (Ohio University, Athens, 15 October–15 November), Art Gallery, University of Notre Dame (Indiana, 1–31 December), Parkersburg Art Center (Parkersburg, W.Va., 1–31 March 1979), Swift Current National Exhibition Center (Swift Current, Saskatchewan, 15 April–15 May), Thorne-Sagendorph Art Gallery (Keene State College, Keene, N.H., 1–30 June), Center for the Visual Arts, Illinois State University (Normal, 15 July–26 August), Museum of Arts and History (Port Huron, Mich., 1–30 September), Baltimore Museum of Art (15 October–25 November), Department of Art, Nicholls State University (Thibodaux, La., 15 January–15 February 1980), Art Exhibition Program, St. Edward's University (Austin, Tex., 1–31 March), John Mariani Art Gallery, University of Northern Colorado (Greeley, 15 April–15 May), Buscaglia-Castellani Gallery, Niagara University (Niagara Falls, N.Y., 1–30 June), Art Gallery, University of Wisconsin (Milwaukee, 15 July–15 August), Spiva Art Center, MSSC Campus (Joplin, Mo., 1–30 September), University Gallery, University of Minnesota (Minneapolis, 1–30 November), University Museum, Southern Illinois University (Carbondale, 15 January–15 February 1981), Kirkland Fine Arts Center, Millikin University (Decatur, Ill., 1–31 March),

Western Wisconsin Regional Arts (La Crosse, Wisc., 15 April–15 May), Roanoke Fine Arts Center (Roanoke, Va., 1–30 September), Quincy Art Club (Quincy, Ill., 15 October–15 November), Mary and Leigh Block Gallery, Northwestern University (Evanston, Ill., 1–31 December), Sunset Center (Carmel, Calif., 15 January–15 February 1982), Art Gallery, College of Southern Idaho (Twin Falls, 1–31 March), Oak Ridge Art Center (Oak Ridge, Tenn., 15 April–15 May), Nicolaysen Art Museum (Casper, Wyo., 1–30 June), St. John's College Art Gallery (Annapolis, Md., 8 September–8 October), The Fine Arts Center (Nashville, Tenn., 1 November–15 January 1983), Dalhousie Art Gallery, Dalhousie University (Halifax, Nova Scotia, 3 February–6 March), Art Gallery, Acadia University (Wolfville, Nova Scotia, 20 March–17 April).

Cincinnati: Cincinnati Art Museum, "Fiftieth-Anniversary Exhibition of the Cincinnati Print and Drawing Circle," 7 September–10 November.

Houston: Janie C. Lee Gallery, "Alexander Liberman Bronzes, Hans Hofmann Paintings," October.

Houston: The Museum of Fine Arts, "The Great Decade of American Abstraction, Modernist Art, 1960–1970," 15 January–10 March.

★ New York: André Emmerich Gallery, "Hans Hofmann Paintings, 1936–1940," 5–24 January.

★ New York: André Emmerich Gallery, "Hans Hofmann: Architectural Projects and Other Works on Paper," 9 November–31 December.

New York: Marlborough Gallery, "Selected Works from the Collection of Carter Burden," 9 May–1 June.

New York: Pace Gallery, "American Painters of the Fifties," 9 February–12 March.

New York: William Pall Gallery, "Spring Exhibition," Spring.

★ Philadelphia: Makler Gallery, "Hans Hofmann," 15 February–16 March.

Port Washington, N.Y.: Port Washington Public Library, "Hans Hofmann, Perle Fine, Carl Holty, Vaclav Vytlacil," 4–29 November.

★ Toronto: David Mirvish Gallery, "Hans Hofmann Major Paintings, 1957–1965," 12 October–6 November.

## 1975

Austin: University of Texas, "American Paintings from the Michener Collection," February. Trav-

eled under joint auspices with the U.S. Information Service until December 28. Partial listing: Museo Nacional de Bellas Artes (Santiago, Chile), Museo de Arte Italiano (Lima, Peru), Biblioteca Luis Angel Arango del Banco de la Republica (Bogotá, Columbia), Museo de Arte Contemporaneo (Caracas, Venezuela).

Bay Harbor Isle, Fla.: Berenson Gallery, "Hans Hofmann, Ludwig Sander," March.

⋆ Birmingham, Ala.: Garage Gallery, "Hans Hofmann," July.

Cambridge, Mass.: Fogg Museum of Art, Harvard University, "The New York School: From the First Generation," 10 December–6 January 1976.

Edmonton, Alberta: Edmonton Art Gallery, "The Collective Unconscious: American and Canadian Art, 1940–1950," 5 December–18 January 1976.

Montreal: Waddington Galleries, 19 April–10 May.

⋆ New York: André Emmerich Gallery, "Hans Hofmann: A Selection of Late Paintings," 17 May–27 June.

New York: The Metropolitan Museum of Art, "Notable Acquisitions, 1965–1975," 6 December–23 March 1976.

New York: The Kennedy Gallery, "The Art Students League of New York, 1875–1975," 6–29 March.

New York: Whitney Museum of American Art, Downtown Branch, "Subjects of the Artists: New York Painting, 1941–1947," 22 April–28 May.

New York: William Pall Gallery, "Post-War American Art," October–November.

⋆ Santa Ana, Calif.: Bowers Museum, "Hans Hofmann: 108 Works," 19 April–15 May.

⋆ Washington, D.C.: Fendrick Gallery, "Hans Hofmann in Provincetown," 9 December–3 January 1976.

### 1976

American Federation of Arts traveling exhibition: "American Master Drawings and Watercolors: Works on Paper from Colonial Times to the Present."

Bonn: Rheinisches Landesmuseum, "Two Hundred Years of American Painting," 30 June–28 July. Traveled to Museum of Modern Art (Belgrade, 14 August–11 September), Galleria d'Arte Moderna (Rome, 28 September–26 October), National Museum of Poland (Warsaw, 12 November–10 December).

Katonah, N.Y.: Katonah Gallery, "American Paintings, 1900–1976: Abstract Expressionism and Later Movements, 1955–1976," 29 May–17 July.

Los Angeles: Ruth Schaffner Gallery, "Small Works," 3–27 March.

⋆ New York: André Emmerich Gallery, "Hans Hofmann: The Years 1947–1952," 3–28 April.

New York: Hirschl and Adler Gallery, "Williams College Alumni Loan Exhibition," 1–24 April.

⋆ New York: Sidney Deutsch Gallery, "Hans Hofmann," 3 February–1 April.

New York: Solomon R. Guggenheim Museum, "Aspects of Post-War Painting in America," 15 October–16 January 1977.

New York: Solomon R. Guggenheim Museum, "Twentieth-Century Drawing: Three Avant-Garde Generations," 23 January–21 March. Traveled to the Staatliche Kunsthalle (Baden-Baden) and the Kunsthalle Bremen (Bremen).

Sydney, Australia: David Jones Art Gallery, "Aspects of Twentieth-Century Art," 10–29 May.

⋆ Washington, D.C.: Hirshhorn Museum and Sculpture Garden, "Hans Hofmann: A Retrospective Exhibition," 14 October–2 January 1977. In conjunction with The Museum of Fine Arts, Houston (4 February–3 April 1977).

Washington, D.C.: Hirshhorn Museum and Sculpture Garden, "The Golden Door: Artist-Immigrants of America, 1876–1976," 20 May–20 October.

### 1977

Albany: New York State Museum, "New York, the State of the Art," 8 October–28 November.

⋆ Baltimore: B. R. Kornblatt Gallery, "Hans Hofmann, Paintings," 2 October–3 November.

Baltimore: Baltimore Museum of Art at the Maryland Science Center, "Two Hundred Years of American Painting," 16 January–6 February. Bicentennial exhibition.

Boston: Thomas Segal Gallery, September. Group exhibition of works on paper.

⋆ Bucharest: "Hans Hofmann," Summer. Organized by the U.S.I.A.

⋆ Houston: Janie C. Lee Gallery, "Hans Hofmann: Thirty-six Works on Paper," 15 January–26 February.

⋆ New York: André Emmerich Gallery, "Provincetown Landscapes, 1934–1945," 8–26 January.

⋆ New York: André Emmerich Gallery, "Hans Hofmann: Drawings, 1930–1944," 10 December–11 January 1978.

⋆ Oxford, England: Museum of Modern Art, "Hans Hofmann: The American Years," 23 April–29 May. In cooperation with United States Information Services, London. Presented in 1978 at the Museum of Fine Arts, Valletta (Malta, May–June) by the American Centre in cooperation with Ministry of Labour, Welfare and Culture.

Palm Beach, Fla.: Hokin Gallery, "Provincetown Paintings," 9 February–7 March.

St. Paul: Minnesota Museum of Art, "American Drawings, 1927–1977," 26 September–29 October. Traveled until June 1979 to National Gallery of Iceland (Reykjavik), Paris, Spanish National Museum of Contemporary Art (Madrid), Museum of Contemporary Art (Caracas), New Cultural Center (Santo Domingo, Dominican Republic), Museum of Modern Art (Mexico City).

San Francisco: John Berggruen Gallery, "American Paintings and Drawings," 30 March–7 May.

Syracuse, N.Y.: Everson Museum, "Provincetown Painters of the 1890s to 1970s," June. Traveled to Provincetown Art Association (Provincetown, Mass., 5 August–5 September).

⋆ Toronto: David Mirvish Gallery, "Hans Hofmann."

### 1978

Basel: "ART 9/78," 14–19 June.

Berlin: Amerika Haus, "Aquarella aus den Jahren 1943–1952," February.

Birmingham, Mich.: Susanne Gilberry Gallery, March.

Boston: Thomas Segal Gallery, "Watercolors," March.

⋆ Buffalo, N.Y.: Nina Freudenheim Gallery, "Hans Hofmann: Drawings, 1930–1944," 11 February–24 March.

Chicago: Richard Gray Gallery, "Works on Paper," April.

Flint, Mich.: Flint Institute of Art, "Art and the Automobile," 12 January–12 March.

Ithaca, N.Y.: Herbert F. Johnson Museum of Art, Cornell University, "Abstract Expressionism: The Formative Years," 28 March–14 May. Traveled to the Seibu Museum of Art (Tokyo, 17 June–12 July), the Whitney Museum of American Art (New York, 5 October–3 December).

Madrid: Museo Español de Arte Contemporaneo, "Dibujos Americans, 1927–1977," October–November.

New York: Harold Reed Gallery, "Selected 20th-Century American Nudes," 16 February–4 March.
Ottawa: United States Embassy, "Eighteen Contemporary Masters," November.
Palm Beach, Fla.: Hokin Gallery, 12–31 December.
Toledo, Ohio: The Toledo Museum of Art, "Art for Collectors V," 12 November–17 December.
Toronto: David Mirvish Gallery, 7–31 January.
Zurich: Galerie André Emmerich, "American Painting," July–August.
* Zurich: Galerie André Emmerich, "Hans Hofmann: Bilder und Werke auf Papier," 3 February–23 March.

### 1979
Amherst, Mass.: Hampshire College Gallery, "Images of the Self," 19 February–14 March.
Boston: Thomas Segal Gallery, "Paper, Clay & Tapestry: Explorations into New Media," 28 April–2 June.
Caracas: Residence of Ambassador Luers, United States Embassy, "Arte en la Embajada," 1979 to 1981.
* Denver: Gallery 609, "Hans Hofmann: Drawings and Paintings," 11 July–31 August.
* Harriman, N.Y.: Harriman College, "Hans Hofmann Drawings," 25 April–1 May.
* New York: André Emmerich Gallery, "Hans Hofmann: Provincetown Landscapes, 1941–1943," 6–31 January.
New York: Knoedler Gallery, "Selections from the Mr. and Mrs. Eugene Schwartz Collection," 31 October–28 November.
New York: The Metropolitan Museum of Art, "Hans Hofmann as Teacher: Drawings by His Students," 23 January–4 March. Expanded exhibition, Provincetown Art Association (Provincetown, Mass., 1 August–12 October 1980).
New York: Salander O'Reilly Galleries, "20th-Century Paintings," October.
Reno, Nevada: Sierra Nevada Museum of Art, "The New York School, 1940–1960," 3 February–4 March.
* Toronto: Marianne Friedland Gallery, "Hans Hofmann: Works on Paper," 3–24 November.
Venice, Calif.: Janus Gallery, "Drawing Explorations, 1930–1978."

### 1980
* Chicago: Richard Gray Gallery, "Hans Hofmann: The Late Small Paintings,

1952–1965," 15 November–December.
Copenhagen: State Museum of Art, "Art in Embassies," 1 May–1 June. Assembled through the Art in Embassies Program in coordination with Ambassador and Mrs. Warren Manshel.
Dallas: NorthPark National Bank, "Three Decades/Oil on Canvas," 27 June–12 September. In conjunction with the André Emmerich Gallery, New York.
Denver: Gallery 609, "Master Drawings, Sculpture, Watercolors," December–January 1981.
Memphis: Audrey Strohl Gallery, "Paintings from the André Emmerich Gallery," 23 May–27 June.
* Montreal: Theo Waddington, "Hans Hofmann: Paintings and Works on Paper," 4–29 March.
* New York: André Emmerich Gallery, "Hans Hofmann: Private-Scale Paintings," 12 January–6 February.
* New York: André Emmerich Gallery, "Hans Hofmann, Centennial Celebration, Part I: Major Paintings," 13 December–13 January 1981.
New York: Harold Reed Gallery, "Selected 20th-Century American Self-Portraits," 18 October–15 November.
* New York: The Metropolitan Museum of Art, "Hans Hofmann: The Renate Series," 2 December–January 1981.
New York: Terry Dintenfass, Inc., "All in Line: An Exhibition of Linear Drawings," 23 November–18 January 1981. Traveled to Joe and Emily Lowe Art Gallery, Syracuse University (Syracuse, N.Y., 31 January–27 February 1981).
Paris: Grand Palais, Société des Artistes, 91e Exposition, "L'Amérique aux Indépendants," 13 March–13 April.
* Provincetown, Mass.: Provincetown Art Association, "Hans Hofmann: Provincetown Scenes," 1 August–12 October. Shown jointly with traveling exhibition "Hans Hofmann as Teacher: Drawings by His Students."
Washington, D.C.: Hirshhorn Museum and Sculpture Garden, "The Fifties: Aspects of Painting in New York," 22 May–21 September.

### 1981
Birmingham, Mich.: Donald Morris Gallery, "Master Works on Paper," 8 August–12 September.
* Boston: Harcus Krakow Gallery, "Hans Hofmann: Paintings and Works on Paper," April.
Caracas: Museum of Contemporary Art, Sala Cadafe, 15 February–15 March.

Cologne: Museen der Stadt Köln, "Westkunst," 30 May–16 August.
* Louisville, Ky.: Martha White Gallery, "Hans Hofmann: Paintings and Drawings," 5–28 November.
Milwaukee, Wisc.: Milwaukee Art Museum, "Center Ring: The Artist, Two Centuries of Circus Art," 7 May–28 June. Traveled to Columbus Museum of Art (Columbus, Ohio, 30 August–11 October), New York State Museum (Albany, 11 December–7 March 1982), The Corcoran Gallery of Art (Washington, D.C., 24 April–6 June).
Munich: Haus der Kunst, "Amerikanische Malerei, 1930–1980," 14 November–31 January 1982. Organized by the Whitney Museum of American Art.
* New York: André Emmerich Gallery, "Hans Hofmann, Centennial Celebration, Part II: Works on Paper," 17 January–14 February.
New York: Grey Art Gallery, New York University, "Tracking the Marvelous," 28 April–May.
New York: Marisa del Re Gallery, "Ten American Abstract Masters," 1–30 May.
* Philadelphia: Makler Gallery, "Hans Hofmann," 2–28 November.
* Santa Monica, Calif.: Asher/Faure Gallery, "Hans Hofmann: Paintings," 30 May–27 June. Presented by André Emmerich.
* Toronto: Marianne Friedland Gallery, "Hans Hofmann: Major Painting and Works on Paper," April.
Washington, D.C.: B. R. Kornblatt Gallery, "Eleven Paintings and Two Sculptures from the Sixties," 7 November–10 December.
Zurich: Gimpel-Hanover and André Emmerich Galerien, "Assoziation zu Blau," 17 January–28 February.

### 1982
American Federation of Arts traveling exhibition: "Hans Hofmann as Teacher: Drawings by Hofmann and His Students," 1982–84. Bass Museum (Miami, 12 December–23 January 1983), Elvehjem Museum of Art, University of Wisconsin (Madison, 6 March–1 May), Museum of Art, University of Arizona (Tucson, 25 September–19 October), Montreal Museum of Fine Arts (13 November–8 January 1984), Community Gallery of Art, Santa Fe Community College (Gainesville, Fla., 5 February–1 April), Art Gallery of Hamilton (Ontario, 10 May–1 July).

Akron, Ohio: Akron Art Museum, "The Blaffer Collection of American Abstract Expressionist Paintings," 28 March–22 May.
Boston: Museum of Fine Arts, "A Private Vision: Contemporary Art from the Graham Gund Collection," 7 February–4 April.
* Edmonton, Alberta: Edmonton Art Gallery, "Hans Hofmann, 1880–1966: An Introduction to His Paintings," 9 July–5 September.
Houston: Contemporary Arts Museum, "The Americans: The Collage," 11 July–3 October.
Houston: The Museum of Fine Arts, "Miró in America," 21 April–27 June.
* New York: André Emmerich Gallery, "Hans Hofmann: The Late Small Paintings," 7–30 January.
New York: Marisa del Re Gallery, "Small Works by Major Artists," 14 December–15 January, 1983.
* Toronto: Marianne Friedland Gallery, "The Drawings of Hans Hofmann," 6–30 March.

**1983**
The Gallery Association of New York State Traveling Exhibition: "Twentieth-Century American Watercolor," 1983–84. To the Collegiate School (New York, 5 April–6 May), Federal Reserve Bank of New York (31 May–12 July), Philadelphia College of Art (9 September–8 October), Towson State University (Towson, Md., 18 November–18 December), Tyler Fine Arts Gallery, State University of New York (Oswego, 1–26 February 1984), University Art Gallery, State University of New York (Albany, 9 March–13 April).
Cairo: United States ambassador's residence, "Art in Embassies Program."
Edmonton, Alberta: Woltjen/Udell Gallery, 8–24 December.
Houston: The Museum of Fine Arts, "Lee Krasner: A Retrospective," 28 October. Traveled to the San Francisco Museum of Modern Art, the Phoenix Art Museum (Arizona), and the Museum of Modern Art (New York), to 8 January 1984.
Los Angeles: Los Angeles Municipal Art Gallery, "Self-Portraits," 18 October–13 November.
Los Angeles: Museum of Contemporary Art, "The First Show: Painting and Sculpture from Eight Collections," 18 November–19 February 1984.
* New York: André Emmerich Gallery, "Hans Hofmann: Paintings on Paper, 1958–1965," 6–29 January.

New York: André Emmerich Gallery, "Six Major Paintings: Francis, Frankenthaler, Gottlieb, Hofmann, Louis, and Stella, 1952–1962," 5–23 March.
New York: André Emmerich Gallery, 9–31 December.
New York: Marilyn Pearl Gallery, "Artists of the Fifties," February.
New York: Salander O'Reilly Galleries, "Selections from the Rose Art Museum, Brandeis," 6–30 April.
Oxford, Ohio: Miami University Art Museum, "Living with Art II: The Collection of Walter and Dawn Clark Netsch," 10 September–16 December. Traveled to the Snite Museum of Art, University of Notre Dame (Indiana, 22 January–25 March 1984).
Pittsburgh: Museum of Art, Carnegie Institute, "Abstract Painting and Sculpture in America, 1927–1944," 5 November–31 December. Traveled to San Francisco Museum of Modern Art (26 January–24 March 1984), Minneapolis Institute of Arts (15 April–3 June), Whitney Museum of American Art (New York, 28 June–9 September).
Scottsdale, Ariz.: Yares Gallery, "Selected Paintings," 20 February–18 March.
Seattle: Linda Farris Gallery, "Self-Portraits," 4 August–11 September. Traveled to Los Angeles Municipal Art Gallery (18 October–13 November).
Toronto: Marianne Friedland Gallery, "Trio," 14 May–10 July. With Milton Avery and Al Held.
* Washington, D.C.: B. R. Kornblatt Gallery, "Hans Hofmann," 20 September–26 October.

**1984**
Arlington: University Art Gallery, University of Texas, "American Abstract Impressionist Paintings," 27 March–19 April.
Chicago: Richard Gray Gallery, "Modern and Contemporary Masters," 11 February–24 March.
Houston: Janie C. Lee Gallery, "Master Drawings, 1928–1984," March–April.
* Kansas City: Douglas Drake Gallery, "Hans Hofmann: Selected Oils and Works on Paper, 1934–1962," 1–30 June.
Madrid: United States ambassador's residence, "Arte Contemporaneo Norteamericano, Coleccion David Mirvish," January.
Miami: Center for the Fine Arts, "In Quest of Excellence: Civic Pride, Patronage, Connoisseurship," 14 January–22 April.

* New York: André Emmerich Gallery, "Hans Hofmann: Explorations of Major Themes: Pictures on Paper, 1940–1950," 7 January–4 February.
New York: Ronald Feldman Fine Arts, Inc., "Socialites and Satellites," 7 April–12 May.
Paris: Artcurial, "Un Art Autre – Un Autre Art," April–July.
Rome: Vatican Museums and International Exhibitions Foundation: "American Masters: The Thyssen-Bornemisza Collection," traveling exhibition, 1984–86, to Baltimore Museum of Art (9 September–28 October), The Detroit Institute of Arts (19 November–20 January 1985), Denver Art Museum (23 February–21 April), Marion Koogler McNay Art Institute (San Antonio, Tex., 18 May–15 July), IBM Gallery of Science and Art (New York, 13 August–19 October), San Diego Museum (16 November–12 January 1986), Society of Four Arts (Palm Beach, Fla., 14 February–20 April), New Orleans Museum of Art (18 May–13 July).
Rydhave, Denmark: American ambassador's residence, "American Art at Rydhave," assembled by Art in Embassies program in coordination with Ambassador John L. Loeb, Jr.
* Scottsdale, Ariz.: Yares Gallery, "Hans Hofmann: Small Scale Paintings," 5–29 February.
* Toronto: Marianne Friedland Gallery, "Hans Hofmann: The Early Interiors, the Late Abstractions, Major Paintings," 31 March–5 May.

**1985**
Chicago: Museum of Contemporary Art, "Selections from the William J. Hokin Collection," 20 April–16 June.
* Fort Worth: Fort Worth Art Museum, "Hans Hofmann: Provincetown Paintings and Drawings," 15 September–17 November.
* Fort Worth: Fort Worth Art Museum, "Hans Hofmann: The Renate Series," 15 September–17 November.
Hempstead, N.Y.: Emily Lowe Gallery, Hofstra Cultural Center, Hofstra University, "Avant-Garde Comes to New York," 5 November–2 January 1986.
* La Jolla, Calif.: Thomas Babeor Gallery, "Hans Hofmann: Paintings and Works on Paper," 8 February–6 April.
Los Angeles: Margo Leavin Gallery, "American Abstract Painting," 19 June–24 August.
New Orleans: New Orleans Museum of Art, "Profile of a Connoisseur: The Collection of

Muriel Bultman," 10 November–12 January 1986.

* New York: André Emmerich Gallery, "Major Paintings, 1954–1965," 5–26 January.

New York: Holly Solomon Gallery, "The Innovative Still Life," 5 June–3 July.

New York: Marisa del Re Gallery, "Masters of the Fifties: American Abstract Painting from Pollock to Stella," October–December.

New York: Stephen Mazoh & Co., Inc., "Twentieth-Century Works of Art," Fall.

Paris: Chapelle des Petits-Augustins, "Cinquante Ans de Dessins Américains, 1930–1980," 2 May–13 July.

Providence, R.I.: Bell Gallery, List Art Center, Brown University, "Flying Tigers: Painting and Sculpture in New York, 1939–1945," 27 April–27 May. Traveled to the Cantor Art Gallery, College of the Holy Cross (Worcester, Mass., 26 April–27 May), The Parrish Art Museum (Southampton, N.Y., 9 June–28 July).

**1986**

Independent Curators Incorporated, traveling exhibition: "After Matisse," 1986–88. Tiffany Bell, Associate Guest Curator, Irving Sandler and Susan Sollins, curatorial consultants. Traveled to the Chrysler Museum (Norfolk, Va., 11 September–9 November), Portland Museum of Art (Portland, Maine, 9 December–9 February 1987), Bass Museum of Art (Miami, 17 March–17 May), The Phillips Collection (Washington, D.C., 19 June–6 August), Dayton Art Institute (Dayton, Ohio, 12 September–8 November), Worcester Art Museum (Worcester, Mass., 9 December–7 February 1988).

Baltimore: C. Grimaldis Gallery, "Grimaldis and Friends at a New Location: Inaugural Exhibition," 4–27 September.

* Baltimore: C. Grimaldis Gallery, "Hans Hofmann: Works on Canvas and Paper," 5–29 March.

* Berkeley: University Art Museum, University of California, "Hans Hofmann," 15 October–15 December.

Chicago: R. H. Love Modern, "Abstraction by American Masters over 50," 12 December–19 January 1987.

Cologne: Museum Ludwig, "Europe/America," 6 September–30 November.

Cologne: Museum Ludwig, "Kunst im 20. Jahrhundert."

Fort Lauderdale, Fla.: Museum of Art, "An American Renaissance: Paintings and Sculpture since 1940," 12 January–30 March.

Minneapolis: John C. Stoller & Co., "Ten on Paper," 27 June–10 September.

New Orleans: Arthur Roger Gallery, 1–30 March. Group exhibition.

* New York: André Emmerich Gallery, "Hans Hofmann, Pictures of Summer: Provincetown, 1941–1942," 8 January–8 February.

New York: Lever/Meyerson Gallery, "Hans Hofmann and His Legacy," 15 October–12 December.

New York: Martina Hamilton Gallery, "Portraits," April–May.

Newport Beach, Calif.: Newport Harbor Art Museum, "The Interpretive Link, Abstract Surrealism into Abstract Expressionism: Works on Paper, 1938–1948," 16 July–14 September. Traveled to Whitney Museum of American Art (New York, 13 November–21 January 1987), Walker Art Center (Minneapolis, 21 February–19 April).

Purchase, N.Y.: Neuberger Museum, "The Window in Twentieth-Century Art," 21 September–18 January 1987. Traveled to Contemporary Arts Museum (Houston, 24 April–29 June), Montgomery Museum of Fine Arts (Montgomery, Ala., 15 November–10 January 1987), R. W. Norton Art Gallery (Shreveport, La., 21 January–18 March), Tucson Museum of Art (Tucson, Ariz., 28 March–7 June), Sunrise Museums (Charleston, W.Va., 19 June–7 August), Bass Museum of Art (Miami Beach, Fla., 19 September–14 November), San Antonio Museum of Art (San Antonio, Tex., 19 December–13 February 1988), Oklahoma Museum of Art (Oklahoma City, 12 March–7 May).

* Toronto: Marianne Friedland Gallery, "Hans Hofmann: Major Paintings, 1934–1944," 19 April–30 May.

Waltham, Mass.: Rose Art Museum, "Selected 20th-Century Paintings," 28 September–2 November.

**1987**

* Baltimore: C. Grimaldis Gallery, "Hans Hofmann: Works on Paper," 5–28 February.

Bielefeld: Kunsthalle der Stadt, "Hans von Marées und die Moderne in Deutschland," 25 October–10 January 1988. Traveled to Kunstmuseum (Winterthur, Switzerland, 31 January–4 April).

Chicago: Richard Gray Gallery, "Modern and Contemporary Masters," 31 January–7 March.

Houston: Janie C. Lee Gallery, "Drawings, 1944–1954," 17 April–17 June.

La Jolla, Calif.: Thomas Babeor Gallery, Summer.

* New York: André Emmerich Gallery, "Hans Hofmann: The Pre-War Years in America," 9 January–7 February.

New York: The Elkon Gallery, "Masters of the Twentieth Century," 20 October–23 December.

Stamford, Conn.: Stamford Museum and Nature Center, "Color: Pure and Simple," 20 September–15 November.

* Toronto: Marianne Friedland Gallery, "The Drawings of Hans Hofmann," 4–29 April.

**1988**

* La Jolla, Calif.: Thomas Babeor Gallery, "Selected Works," 9 July–27 August.

* London: Tate Gallery, "Hans Hofmann: Late Paintings," 2 March–1 May.

Montreal: Landau Fine Art, "Inaugural Exhibition: 19th- and 20th-Century Masters," Summer.

New York: Acquavella Galleries, "XIX and XX Century Master Paintings and Sculpture," 1 November–1 December.

* New York: André Emmerich Gallery, "Selected Works," 3–27 May.

New York: CDS Gallery, "The Irascibles," 4–27 February.

New York: Janie C. Lee Master Drawings, "Abstract Expressionist Drawings, 1941–1955," 5 November–30 December.

Rochester, Mich.: Meadow Brook Art Gallery, Oakland University, "Contemporary Art from the Collection of Marion and David Handleman," 2 October–6 November.

* Toronto: Marianne Friedland Gallery, "Hans Hofmann: Important Paintings and Works on Paper," 5–24 November.

**1989**

Coral Gables, Fla.: Lowe Art Museum, "Abstract Expressionism: Other Dimensions," 26 October–3 December. Traveled to Terra Museum of American Art (Chicago, 23 January–11 March 1990), The Jane Voorhees Zimmerli Art Museum, Rutgers (New Brunswick, N.J., 24 March–13 June), Whitney Museum of American Art at Philip Morris (New York, 5 October–5 December).

Montreal: Galerie Claude Lafitte, "Renoir à Riopelle," 24 October–18 November.
* New York: André Emmerich Gallery, "The Post-War Years, 1945–1949," 12 January–18 February.
New York: Barbara Mathes Gallery, "Selections: Fall 1989," Autumn.
New York: Whitney Museum of American Art, Downtown at Federal Reserve Plaza, "The Gestural Impulse, 1945–1960," 28 September–1 December.
San Francisco: John Berggruen Gallery, "Paintings, 1937–1961," 19 April–20 May.

### 1990
* Baltimore: C. Grimaldis Gallery, "Hans Hofmann: Works on Paper," 5–28 April.
Katonah, N.Y.: The Katonah Museum of Art, "Watercolors from the Abstract Expressionist Era," 1 April–3 June.
* London: Crane Gallery, "Thirty-five Paintings and Watercolors by Hans Hofmann," 13 June–25 July. "A Selection of Paintings and Watercolors" traveled to Galerie Michael Haas (Berlin, September–October) and Galerie Zwirner (Cologne, November–December).
* Miami: Center for the Fine Arts, "Hans Hofmann," 20 November–December.
* Munich: Galerie Thomas, "Hans Hofmann: Gemälde und Aquarelle," 10 May–21 July.
* New York: André Emmerich Gallery, "Hans Hofmann: Paintings on Paper from the 1940s," 6–27 January.
* New York: André Emmerich Gallery, "Hans Hofmann: The 1950 Chimbote Mural Project," 20 December–26 January, 1991.
* New York: André Emmerich Gallery, "Hans Hofmann: Works on Paper from the Summer of 1941," 31 May–29 June.
New York: Linda Hyman Fine Arts, "20th-Century Works on Paper," April.
New York: Stux Modern, "Abstract Expressionists: Studio 35/Downtown," November.
* New York: Whitney Museum of American Art, "Hans Hofmann: Retrospective Exhibition," 21 June–17 September. Traveled to Center for the Fine Arts (Miami, November–1 January 1991) and the Chrysler Museum (Norfolk, Va., 17 February–14 April).
Provincetown, Mass.: Provincetown Art Association and Museum, "The Provocative Years, 1935–1945: The Hans Hofmann School and Its Students in Provincetown," 3 August–28 October.

Tokyo: The Fuji Television Gallery, "The 20th Anniversary," 2–26 April.
Toronto: Marianne Friedland Gallery, "Master Works, Contemporary and Modern," November.

### 1991
Cologne: Museum Ludwig, "Die Hand des Künstlers (The Hand of the Artist)," 27 April–23 June.
London: Crane Gallery, "Affinities in Paint," 14 June–31 July.
Naples, Fla.: Marianne Friedland Gallery, "Inaugural Exhibition: Master Works, Contemporary and Modern," January.
* New York: André Emmerich Gallery, "Projects for Mosaic Walls," 19 October–16 November.
New York: Sidney Janis Gallery, "Who Framed Modern Art, or the Quantitative Life of Roger Rabbit," 10 January–16 February.
New York: The Museum of Modern Art, "Art of the Forties," 24 February–30 April.
New York: Twining Gallery, "The Nude: Drawings of the Figure by New York School Artists circa 1930–1950."

### 1992
Berlin: Galerie Michael Haas, "Aus den Beständen der Galerie, 1992," May.
Jacksonville, Fla.: Cummer Gallery of Art, "Abstract Expressionism: The Haskell Collection," 17 April–28 June.
New York: André Emmerich Gallery, "Alechinsky, Caro, Francis, Frankenthaler, Held, Hofmann, Morris Louis, McLaughllin, Noland, Olitski," 8 September–3 October.
New York: Sid Deutsch Gallery, "American Cubism, 1909–1949," 9 May–3 June.
Potsdam: Gibson Gallery, Potsdam College of the State University of New York, "From Omaha to Abstract Expressionism: American Artists' Responses to World War II," 6 March–5 April.
Santa Fe: Riva Yares Gallery, "Pioneers of American Abstract Art: Milton Avery and Hans Hofmann," 16 October–7 November.
* Toronto: Marianne Friedland Gallery, "Hans Hofmann: The Provincetown Paintings," May.
Washington, D.C.: The Phillips Collection, "Theme & Improvisation: Kandinsky and the American Avant-Garde, 1912–1950," 19 September–29 November. Traveled to Dayton Art Institute (Dayton, Ohio, 12 December–31 January 1993), Terra Museum of American Art (Chicago, 13 February–25 April), Amon Carter Museum (Fort Worth, 14 May–1 August).

### 1993
* New York: André Emmerich Gallery, "Hans Hofmann: Selected Works," 7 January–10 February.

### 1994
Boston: Boston University Art Gallery, "Provincetown Prospects: The Work of Hans Hofmann and His Students," 22 January–27 February.
Nagaoka, Japan: Niigata Prefectural Museum of Modern Art, "Masterworks of Modern Art from the Art Institute of Chicago," 20 April–29 May. Traveled to Aichi Prefectural Museum of Art (Nagoya, 10 June–24 July), Yokohama Museum of Art (6 August–25 September).
* New York: André Emmerich Gallery, "Hans Hofmann Paintings Large and Small," 17 November–14 January, 1995.
New York: Michael Rosenfeld Gallery, "Abstraction in American Art, On Paper," 9 June–12 August.
New York: New York Studio School, "The Brushstroke and Its Guises," 7 March–16 April.

### 1995
Berlin: Galerie Michael Haas, "Malwut und Leidenschaft," 20 May–15 July.
London: Annely Juda Fine Art, "1945: The End of the War," 28 June–16 September.
Naples, Fla.: Marianne Friedland Gallery, "Collector's Choice: Painting and Sculpture," January.
* New York: André Emmerich Gallery, "Hans Hofmann's America: Landscapes, Still Lifes and Abstractions," 7 December–20 January 1996.
New York: Whitney Museum of American Art, "Views from Abroad: European Perspectives on American Art I," 29 June–1 October. Traveled to Stedelijk Museum (Amsterdam, "Amerikaanse Perspectieven: Europese Visies op Amerikaanse Kunst 1," 17 November–28 January 1996).
* Toronto: Drabinsky & Friedland Galleries, "Hans Hofmann: The Provincetown Paintings," 28 October–November.

### 1996
Münster, Germany: Westfälische Landesmuseum für Kunst und Kulturgeschichte, "Farben des Lichts: Paul Signac und der Beginn der Moderne von Matisse bis Mondrian," 1 December–16 February 1997. Traveled to Musée de Grenoble (9 March–25 May) and Kunstsammlungen zu Weimar (15 June–31 August).

* New York: André Emmerich Gallery, "Push-Pull," 14 November–7 December.
Seattle: Meyerson & Nowinski, "The Geometric Tradition in American Art," 5 September–
3 November.
Tokyo: Sezon Museum, "Abstract Expressionism," 6 June–14 July. Traveled to Aichi Prefectural Museum of Art (Nagoya, 26 July–
16 September) and Hiroshima City Museum of Contemporary Art (29 September–
17 November).

## 1997
* Munich: Städtische Galerie im Lenbachhaus, "Hans Hofmann: Wunder des Rhythmus und Schönheit des Raumes (The Wonder of Rhythm and the Beauty of Space)," 23 April–29 June. Traveled to Schirn Kunsthalle (Frankfurt, 12 September–2 November).
* Santa Fe: Riva Yares Gallery, "Hans Hofmann: Selected Paintings," 27 June–30 July.

# Selected Bibliography

**Texts by Hofmann (arranged chronologically)**

"Art in America." *Art Digest* 4, no. 19 (August 1930), p. 27.

"Painting and Culture." *Fortnightly* (Campbell, Calif.) 1, no. 1 (11 September 1931), pp. 5–7.

"On the Aims of Art." Translated by Ernst Stolz and Glenn Wessels. *Fortnightly* (Campbell, Calif.) 1, no. 13 (26 February 1932), pp. 7–11.

"Plastic Creation." *The League* (published by the Art Students League, New York) (Winter 1932–33), pp. 11–51, 21. Translated from the German. Reprinted in *The League* 22, no. 3 (Winter 1950), pp. 3–6.

*The Search for the Real and Other Essays.* Exhibition catalogue. Edited by Bartlett H. Hayes, Jr., and Sara T. Weeks. Andover, Mass.: Addison Gallery of American Art, 1948. Reprinted by Cambridge, Mass.: MIT Press, 1983. Includes "The Search for the Real in the Visual Arts," pp. 46–54; "Sculpture," pp. 55–59; "Painting and Culture," pp. 60–64; excerpts from the teaching of Hans Hofmann adapted from his essays "On the Aims of Art" and "Plastic Creation," pp. 65–76 and 76–78.

"Form und Farbe in der Gestaltung." Composed in German 1904–48. Translated by Glenn Wessels in 1931 as "Creation in Form and Color: A Textbook for Instruction in Art." Rewritten as "Das Malerbuch: Form und Farbe in der Gestaltung." Translated by Georgina M. Huck, 1938–48.

Statement, dated 30 October 1949. In *Hans Hofmann: Recent Paintings.* Exhibition announcement. New York: Kootz Gallery, 1949.

"Space Pictorially Realized through the Intrinsic Faculty of the Colors to Express Volume," dated 26 September 1951. In *New Paintings by Hans Hofmann.* Exhibition catalogue. New York: Kootz Gallery, 1951), p. 4.

"A Statement by Hans Hofmann." In *Hans Hofmann: Recent Paintings.* Exhibition catalogue. New York: Kootz Gallery, 1952.

"The Mystery of Creative Relations" and "The Resurrection of the Plastic Arts." *New Ventures* (July 1953), pp. 20–23. Reprinted in *Hans Hofmann: New Paintings.* Exhibition catalogue. New York: Kootz Gallery, 1954, pp. 2–3.

"The Color Problem in Pure Painting: Its Creative Origin." In *Hans Hofmann: New Paintings.* Exhibition catalogue. New York: Kootz Gallery, 1955, pp. 2–4. Reprinted in *Arts in Architecture* (February 1956), pp. 14–15, and in Sam Hunter, *Hans Hofmann.* New York: Harry N. Abrams, 1963.

"Nature and Art: Controversy and Misconceptions," dated 26 October 1957. In *Hans Hofmann: New Paintings.* Exhibition catalogue. New York: Kootz Gallery, 1958, pp. 3–4.

Statement. In *It Is,* no. 3 (Winter 1958–Spring 1959), p. 10.

"Space and Pictorial Life." *It Is,* no. 4 (Autumn 1959), p. 10.

"Hans Hofmann on Art." *Art Journal* 22 (Spring 1963), pp. 180, 182. Speech delivered at inauguration of Hopkins Center, Dartmouth College, Hanover, N.H., 17 November 1962.

"The Painter and His Problems: A Manual Dedicated to Painting." Thirty-five-page typescript, dated 21 March 1963. Library, The Museum of Modern Art, New York.

"Selected Writings on Art." Undated 117-page typescript compiled by William Seitz, 1963. Library, The Museum of Modern Art, New York. Includes essays printed in *Search for the Real* and selected items above.

## Published Interviews

Jaffe, Irma. "A Conversation with Hans Hofmann." *Artforum* 9 (January 1971), pp. 34–39.

Kuh, Katherine. *The Artist's Voice: Talks with Seventeen Artists,* New York: Harper and Row, 1962, pp. 118–29.

van Okker, William H. "Visit with a Villager: Hans Hofmann." *Villager* (Greenwich Village, New York), 18 March 1965.

Wolf, Ben. "The Digest Interviews Hans Hofmann." *Art Digest* 19 (1 April 1945), p. 52.

## Books, Catalogues, and Articles

Baker, Elizabeth C. "Tales of Hofmann: 'The Renate Series.'" *Artnews* 71 (November 1972), pp. 39–41.

Bannard, Walter Darby. *Hans Hofmann: A Retrospective Exhibition.* Exhibition catalogue. Houston: The Museum of Fine Arts, 1976.

Bultman, Fritz. "The Achievement of Hans Hofmann." *Art News* 62, no. 5 (September 1963), p. 54.

Coates, Robert. "The Art Galleries, at Home and Abroad." *New Yorker* 22, no. 7 (30 March 1946), p. 83.

Ellsworth, Paul. "Hans Hofmann, Reply to Questionnaire and Comments on a Recent Exhibition," *Arts and Architecture* 66, no. 11 (November 1949), pp. 22–28, 45–47.

Goodman, Cynthia. "Hans Hofmann as Teacher." *Arts Magazine* 53 (April 1979), pp. 22–28.

_____. *Hans Hofmann.* Munich: Prestel-Verlag, 1990.

_____. *Hans Hofmann.* New York: Abbeville Press, 1986.

Greenberg, Clement. *Hans Hofmann.* Paris: The Pocket Museum, 1961.

_____. *Art and Culture.* Boston: Beacon Press, 1961.

Hunter, Sam. *Hans Hofmann.* New York: Harry N. Abrams, 1963.

Kinkead, Gwen. "The Spectacular Fall and Rise of Hans Hofmann." *Art News* 79, no. 6 (Summer 1980), p. 90.

de Kooning, Elaine. "Hans Hofmann Paints a Picture." *Art News* 48, no. 10 (February 1950), p. 38.

Kroll, Jack. "Old Man Crazy about Painting." *Newsweek* 62 (16 September 1963), pp. 88, 90.

Landau, Ellen G. "The French Sources for Hans Hofmann's Ideas on the Dynamics of Color-Created Space." *Arts Magazine* 51, no. 2 (October 1976), pp. 76–81.

*Life* 42, no. 14 (8 April 1957), p. 70.

Loran, Erle. "Hans Hofmann and His Work." *Artforum* 2, no. 11 (May 1964), p. 34.

Matter, Mercedes. "Hans Hofmann." *Arts and Architecture* 63 (May 1946), pp. 26–28.

Plaskett, J. "Some New Canadian Painters and Their Debt to Hans Hofmann." *Canadian Art* 10 (Winter 1953), pp. 59–63.

Pollet, Elizabeth. "Hans Hofmann." *Arts Magazine* 31 (May 1957), pp. 30–33.

Riley, Maude. "Hans Hofmann: Teacher-Artist." *Art Digest* 18, no. 12 (15 March 1944), p. 13.

Rose, Barbara. "Hans Hofmann: From Expressionism to Abstraction." *Arts Magazine* 53, no. 3 (November 1978), pp. 110–14.

Rosenberg, Harold. "Hans Hofmann's 'Life' Class." *Portfolio and Art News Annual* 6 (Autumn 1962), pp. 16–31, 110–15.

_____. "Teaching of Hans Hofmann." *Arts Magazine* 45 (December 1970), pp. 17–19.

Ruthenberg, Peter. *Vergessene Bilder: 8 Studenten der "Schule für Bildende Kunst, Hans Hofmann, München" (1915–1932).* Exhibition catalogue. Berlin and Frankfurt: Peter Ruthenberg, 1986.

Sandler, Irving. *The Triumph of American Painting: A History of Abstract Expressionism.* New York: Praeger, 1970.

_____. "Hans Hofmann: The Pedagogical Master." *Art in America* 61 (May 1973), pp. 49–57.

_____. *The New York School: The Painters and Sculptors of the Fifties.* New York: Harper & Row, 1978.

Seckler, Dorothy Gees. "Can Painting Be Taught?" *Art News* 50 (March 1951), pp. 39–40, 63–64.

_____. *Provincetown Painters, 1890s–1970s.* Exhibition catalogue. Syracuse, N.Y.: Everson Museum of Art, 1977.

Seitz, William C. *Hans Hofmann.* Exhibition catalogue. New York: The Museum of Modern Art, 1963.

Wight, Frederick S. *Hans Hofmann,* Berkeley: University of California Press, 1957.

Willard, Charlotte. "Living in a Painting." *Look* 17 (28 July 1953), pp. 52–55.

## Archives

Archives of American Art, Smithsonian Institution, Washington, D.C.

Bancroft Library, University of California, Berkeley.

## Lenders to
## the Exhibition

Berkeley Art Museum, University of California
Galerie Michael Haas, Berlin
Onnasch Collection, Berlin
Modern Art Museum of Fort Worth
Crane Kalman Gallery, London
Tate Gallery, London
Städtische Galerie im Lenbachhaus, Munich
Yale University Art Gallery, New Haven,
Connecticut
André Emmerich Gallery, a division of
Sotheby's, New York
The Metropolitan Museum of Art, New York
Philadelphia Museum of Art
Hirshhorn Museum and Sculpture Garden,
Smithsonian Institution, Washington, D.C.
and private lenders who wish to remain anony-
mous

# Credits